Whistler, Sargent, and Steer

Impressionists in London from Tate Collections

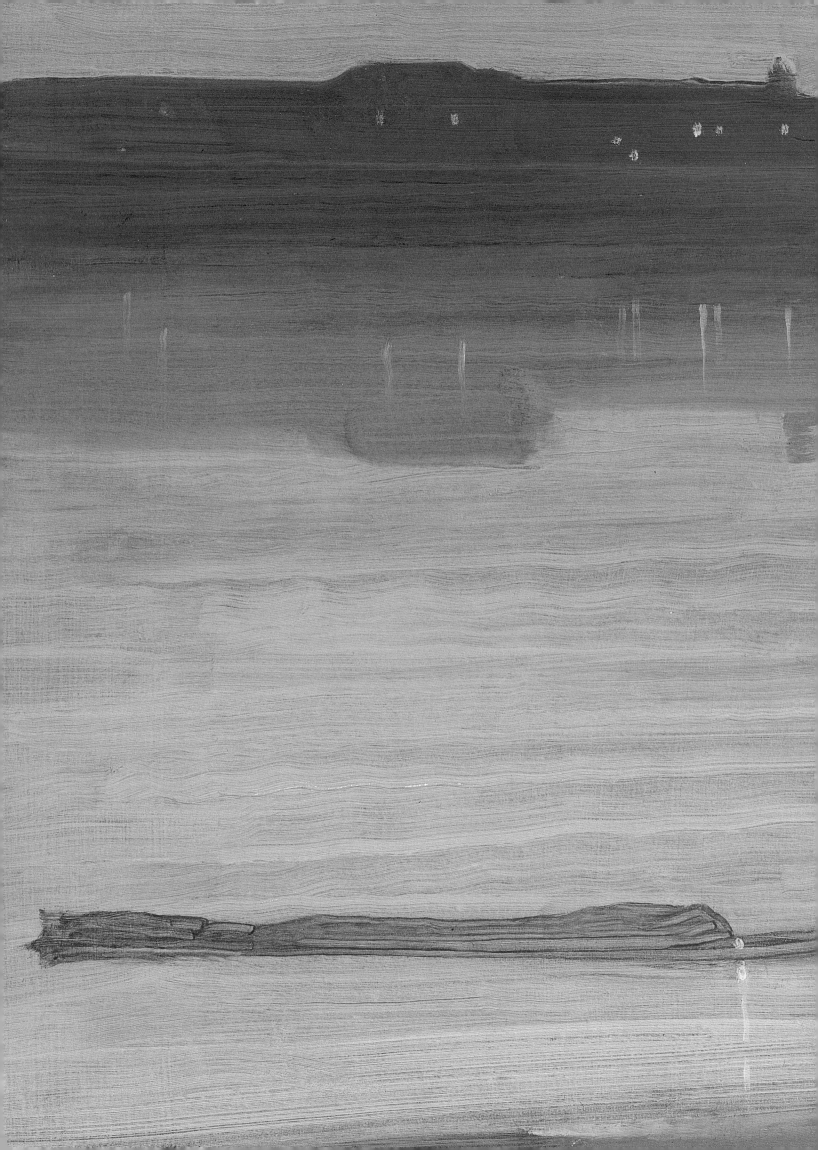

Impressionists

Whistler, Sargent, and Steer

in London

from

Tate Collections

FOREWORD BY
Chase W. Rynd

INTRODUCTION BY
Sandy Nairne

ESSAYS BY
David Fraser Jenkins and
Avis Berman

Frist Center for the Visual Arts

NASHVILLE, TENNESSEE

CENTER FOR THE VISUAL ARTS

Frist Center for the Visual Arts
Nashville, Tennessee
October 11, 2002–January 5, 2003
An exhibition organized in collaboration with Tate
London.

Library of Congress Control Number: 2002107554
ISBN: 0-9706979-8-8 (cloth)
ISBN: 0-9706979-9-6 (paper)

Cover: (top) James McNeill Whistler, *Three Figures:
Pink and Grey* (detail), 1868–78 (cat. 5); (middle)
John Singer Sargent, *The Misses Hunter* (detail), 1902
(cat. 17); (bottom) Philip Wilson Steer, *The Beach
at Walberswick* (detail), ca. 1889 (cat. 29)

Frontispiece: James McNeill Whistler, *Nocturne:
Blue and Silver—Chelsea* (detail), 1871 (cat. 3)

Pages 46–47: Philip Wilson Steer, *Girls Running,
Walberswick Pier* (detail), 1888–94 (cat. 34)

Copyedited by Fronia W. Simpson
Designed by Susan E. Kelly
Produced by Marquand Books, Inc., Seattle
 www.marquand.com

Printed and bound by CS Graphics Pte., Ltd.,
Singapore

Contents

Foreword and Acknowledgments

The Frist Center for the Visual Arts is dedicated to exhibiting and interpreting the finest examples of the art of the world. To accomplish this ambitious goal, it is incumbent on us to cultivate relationships with museums and collectors around the globe—those who care for the artistic patrimony that nourishes our appreciation for the diversity of world cultures, while enabling us to discover mutual interests and experiences that cut across boundaries of time and space.

As we began building international relationships over three years ago, we very fortuitously made an early contact with Tate in Britain. I had the pleasure of meeting with Sandy Nairne, Director: Programmes at Tate, who was just establishing Tate's International Programme. This program was intended to heighten the visibility of Tate's extraordinary collections through the creation of exhibitions that would be seen around the world.

From this timely confluence of institutional imperatives arose an immediate recognition that each of our interests would be well served by a collaboration. Early discussions with Sandy and the International Programme's manager, Joanne Bernstein, yielded the germinal concept that ultimately grew into the present exhibition, *Whistler, Sargent, and Steer: Impressionists in London from Tate Collections*.

We were and remain thrilled, for we could not have envisioned a more prestigious and enthusiastic partner than Tate. I wish to express my heartfelt gratitude to Sandy Nairne and to Sir Nicholas Serota, Director of Tate, for showing their faith and trust in our fledgling institution.

It has been a rewarding opportunity to work with David Fraser Jenkins, whose deft curatorial skills have brought focus and cohesion to the exhibition and whose essay provides an exceptionally thought-provoking look at the lives and work of our three featured artists. Joanne Bernstein is very efficient, and her enthusiastic involvement in this project kept us on track and on time. My sincere thanks to both David and Joanne for making this singular opportunity a reality for us.

We are also fortunate to have enticed Avis Berman to contribute her insightful catalogue essay, which enlightens us even more about the social milieu in fin-de-siècle London that swirled around the upper echelon of British artists. By supporting the scholarly research and writing of both Ms. Berman and Mr. Jenkins, the Frist Center has, for the first time, fulfilled its interest in contributing new and original material to the annals of art history. This effort is a proud beginning for us.

The exhibition could not have materialized without the steadfast efforts of the Frist Center staff. Early on, former curator Candace Adelson provided guidance to the planning process. Curator Mark Scala subsequently shepherded this project through to its successful completion, all the while providing an intelligent and steady hand. My appreciation to both Mark and Candace. Critically important contributions were also made by Assistant Curator Katie Delmez Welborn, Exhibition Designer Dan Reiser, Associate Registrar Amie Geremia, and Education Director Anne Henderson and her staff.

Thanks are also due to Fronia W. Simpson, whose editorial contribution to this publication was, as ever, judicious and subtle. We are fortunate indeed to have had Marquand Books, Inc., coordinate the production of the catalogue, and we are particularly indebted to Susan E. Kelly for its elegant design.

A final word of gratitude must be extended to the Frist Center for the Visual Arts' Board of Trustees, particularly Chairman Dr. Thomas F. Frist, Jr., and President Kenneth L. Roberts, for their unwavering encouragement and support of this project. The staff is proud to have worked on their behalf to bring these marvelous paintings to Nashville.

Chase W. Rynd, *Executive Director*
Frist Center for the Visual Arts

Preface

I have something to tell you. I'm reducing nature to a system.
I'm getting things to a state of absolute perfection. Just wait!

—James McNeill Whistler to Mortimer Menpes
(Menpes, *Whistler As I Knew Him* [London, 1904], 18)

Whistler was the embodiment of the modern type of artist: an artist determined to take on the world, and any confrontation with critics or fellow artists, in pursuit of a future ideal. But his attitude and combative stance belie the legacy of his consummately beautiful paintings. For Whistler's paintings introduce, for Britain, a kind of painting that was crucially important: one that would acknowledge changes in the modern scene and the need to find a modern idiom, while recognizing the importance of the past, of the legacy of the great painters, designers, and colorists of earlier periods. But the world that Whistler encountered, as also for Sargent and Steer, was one balanced between the Victorian period of apparent stability and settled values and the onset of a new century of war and industrial and social strife. These three painters encapsulate this particular moment—people and places at a time of great change—in ways that now seem peculiarly timeless.

This exhibition has been made under the auspices of Tate's International Programme. This is a program intended to create new cultural links for Tate around the world, and to share the collection with those who may not be familiar with it. In particular, it allows Tate's responsibility as the national collection of British and modern art to be given a wider compass: an understanding of the Tate Collection being greatly enhanced by being set in an international context.

I am delighted that this exhibition drawn from the Tate Collection is being presented at the new Frist Center for the Visual Arts in Nashville. Not only does it offer the chance to bring to Nashville works of international importance from London, but it also offers the chance to consider these three artists together and to enjoy the juxtaposition of their works. For this I am very grateful to Chase W. Rynd, as Director of the Frist Center, for the opportunity he has created, and to Gail and Barry Lord, who first made the suggestion that a collaboration with Tate might prove a fruitful part of the early program being planned for Nashville. Its realization has been possible through both the curatorial thinking and insights of David Fraser Jenkins and the diligence and expertise of Joanne Bernstein, the first appointed manager of Tate's International Programme. This effort has been matched by the care and attention brought to the project by the Frist Center staff past and present, particularly Candace Adelson and Mark Scala, and I am grateful to them all.

Sandy Nairne
Director: Programmes, Tate

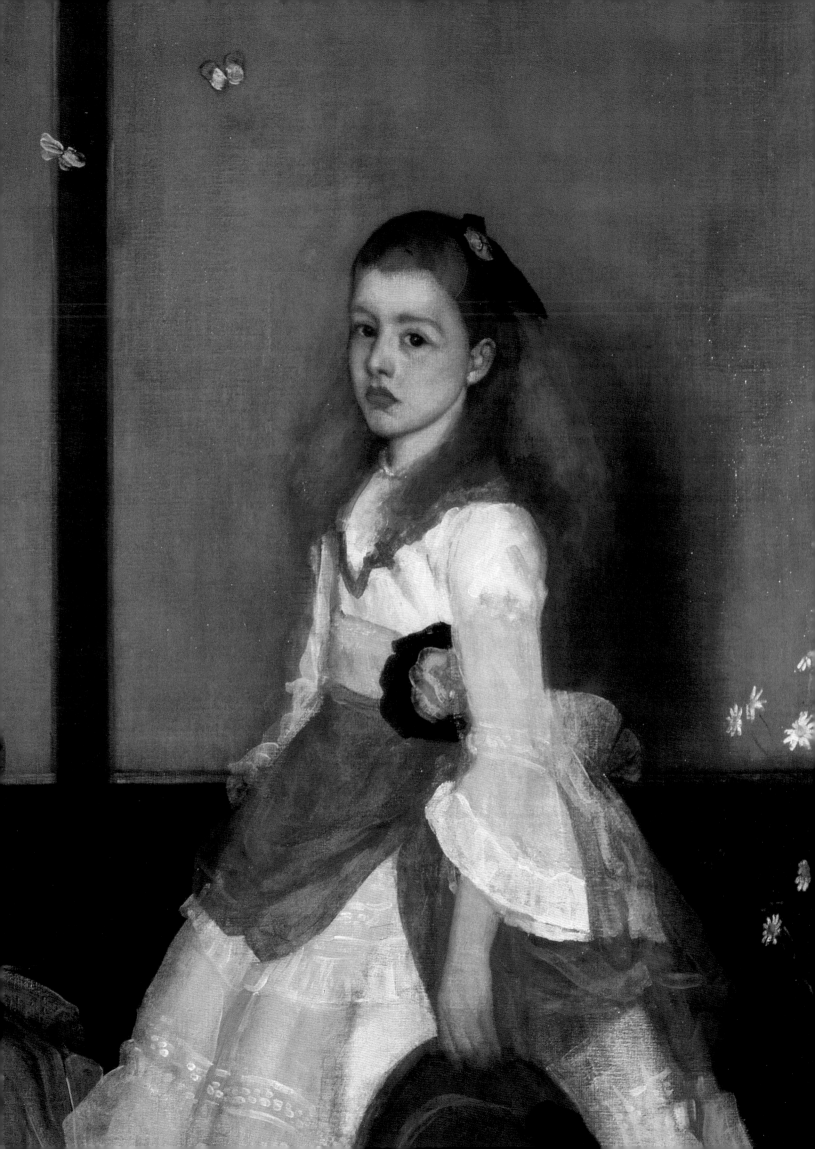

Nocturnes, Characters, and Sunlit Beaches

Whistler, Sargent, and Steer

DAVID FRASER JENKINS

TATE AND FRIST

It is appropriate, as well as a pleasure, to show these paintings by James McNeill Whistler, John Singer Sargent, and Philip Wilson Steer in Nashville so soon after the opening of the Frist Center, since they were created at about the same time as the original foundation of the Tate Gallery in London, to which they now belong (fig. 1). The first years of the Frist at Nashville thus reflect through this exhibition the early years of the Tate in London, and this is an occasion to look back through time to London in the 1890s, and to what has persisted and what has changed in the immense appeal of these pictures. In a sense this exhibition in Nashville in the year 2002 celebrates the opening of not two but three public art galleries: the Frist Center; the centenary of Sir Henry Tate's gallery; and the opening of another entirely new gallery, Tate Modern (fig. 2), which opened in London in May 2000, following the division of the original Tate into two buildings, renewing the commitment to contemporary art in a new setting. The Tate Gallery in 1897 and Tate Modern and the Frist in 2000 and 2001 all provided a new interface between a population who lacked access to a certain kind of art and the satisfying of that need with art exhibitions.

The Tate is not one of the old art galleries of Europe, like the former royal collections of the Musée du Louvre or the Museo del Prado. It opened to the public only in August 1897 and so celebrated its centenary quite recently. The founder was Sir Henry Tate, a successful food retailer and industrialist who owned factories in Liverpool and London that refined imported sugar, which his firm was the first in Britain to sell in cubes. With his personal wealth he bought a mansion on the southern boundaries of London, almost in the countryside, to which he added a picture gallery where he displayed paintings by modern British artists. This was a period when contemporary art was popular, and Tate was a follower of the new exhibitions of his favorite artists, many of whom he knew personally. There was then no public art gallery in London that collected and displayed the work of living artists, despite the fact that there were prominent exhibitions arranged by picture dealers and by groups of artists themselves, such as the annual show at the Royal Academy of Arts. When he was in his sixties, Tate offered money to the government to build a gallery that would show both historic and modern British art, and suggested that his own collection act as a foundation. It is very likely that he saw this as part of public education, since he also funded a number of new public libraries in south London and had previously given money to hospitals and libraries in Liverpool and to educational foundations of the Unitarian Church. After a little delay and hesitancy on the part of the government, the gallery was completed and given the official title The National Gallery of British Art, although from the beginning it was generally called Tate's Gallery, eventually becoming the Tate Gallery.

The Tate Gallery's collection was formed from four groups of art, two private and two public: transfers from London's National Gallery; gifts from the Royal Academy of Art's Chantrey Collection; a personal gift of his own paintings from one of Britain's most admired artists, George Frederic Watts; and Tate's gift of sixty-five pictures. These became the basis of a permanent collection, quite enough for the five rooms of the new building, and gave a welcome emphasis to contemporary art. It was

James McNeill Whistler, *Miss Cicely Alexander: Harmony in Grey and Green* (detail), 1872 (cat. 4)

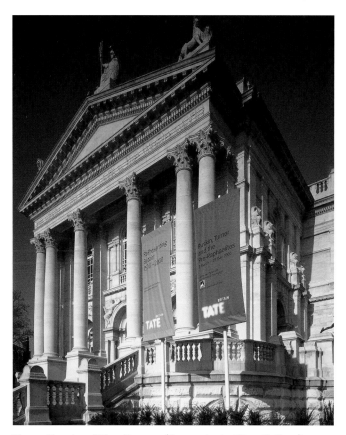

Fig. 1. Facade of Tate Britain (formerly the Tate Gallery).
© Tate London, 2002

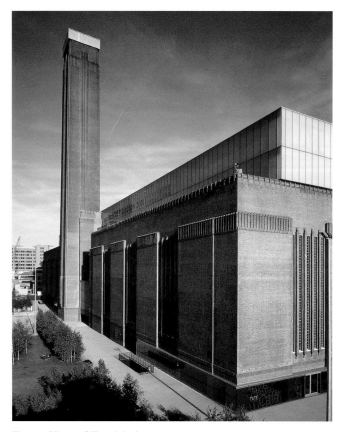

Fig. 2. View of Tate Modern.
© Tate London, 2002

effectively a display of modern art, with a few antecedents, and all of it British.

The Tate Gallery was popular from the start and earned encouraging reviews in the newspapers and journals at a time when there was an incredibly large number of published art notices. There had evidently been a need for a public gallery that collected and displayed modern British art, since at the Academy and elsewhere new pictures and sculptures were visited and reviewed and bought in reproductions, and the press of the time expressed the opinion that the art available in London was the best anywhere in the world. But the three artists of this exhibition, who were all alive and in full production in the 1890s, did not have paintings in Tate's collection, as each of them was considered too unconventional.

So for the first few years of the Tate Gallery, only Sargent was shown there, and then only by a single painting—and this was a remarkable exception, a grand Impressionist painting by Sargent that had been bought by the Royal Academy for a record sum in 1887 on its first exhibition. There is no record of what the three artists thought of the gallery, and they were not among the few artists invited to the official royal opening. The younger two, Sargent and Steer, no doubt visited, but Whistler was then unwell and staying in a London hotel (sometimes borrowing a studio from Sargent), and he spent part of the summer of 1897 in Dieppe, France. It is not likely that he would have been interested in a sight of Henry Tate's paintings, and he was quite out of fashionable London life.

Looking back now to London's art galleries in the 1890s, it still seems extraordinary that these artists, now among the best known of all and whose paintings are among the great strengths of the Tate Gallery, did not have better official recognition, even though other kinds of modern art were much admired. It was a complicated situation, for they were in fact well known in various ways, and Sargent was very prominently at the beginning of his triumph as a portraitist. But the story of the general disapproval of new styles of art since Impressionism is well known—so much so that until recently the reverse misjudgment was almost taken for granted, that modern art in

the best taste was characterized as an art that had little popular following. The equivalent situation now, when the Frist Center opened in Nashville in 2001, would have been for many celebrated American artists to be shown there, with the omission of such well-known names as . . . but it is not for me to say who might have been left out, because I am just such an art museum official who would not in all confidence have thought twice of omitting the Impressionists in their own day.

BRITAIN AND AMERICA

To look now at the opening of the Tate Gallery a hundred years ago and to compare it with the beginnings of the Frist Center is, of course, to look from America at an event in Britain and to realize that British and American art of the time is not at all well known in the other country. This, despite the fact that two of the painters in this exhibition were American expatriates who chose to live in Europe, and exceptionally are now famous on both sides of the Atlantic. That Whistler and Sargent retained their American citizenship for their lifetimes (Sargent declining in 1907 to forego his nationality for the sake of accepting from Edward VII the offer of a knighthood) and that it is difficult to discern a nationality in their painting indicate that their art is indeed international. Both of them had been art students in Paris, where Whistler had also lived for long periods, and rather than contrast American with British it would be more accurate to classify all these artists as foreign Ambassadors to the Court of Art in France who later lived in Britain, with French medals to add to their own skills. The third artist, Philip Wilson Steer, was British and not much of a traveler, but he also studied in Paris, which prepared him for the impact of modern French art after he had returned to London, where he saw and exhibited with Sargent in Impressionist exhibitions.

Whistler was a generation older than the other two (who were much the same age), and he was one of the great innovators of modern painting. Without him, the course of art would certainly have been different. In the 1870s, when he painted the pictures of the river Thames which he called *Nocturnes*,

there was no one like him in London. He came to have a large number of admirers and followers, and some imitators, in Britain and America. For the careers of many of these artists, it was a question of passing through a Whistler-like phase, painting pictures with a refined twilight coloring, depicting city streets and interiors. This attention to a beautiful technique and to the everyday as subject enlarged many artists' taste and led to an admiration for the sunlit naturalism of the French Impressionists Claude Monet and Camille Pissarro as a desirable point of departure, and so to a much brighter coloring of their own pictures. By the time of the next generation's coming of age, in the late 1880s and early 1890s, there were many followers of Monet alongside Sargent and Steer, and even though they were set against the traditionalists of the Academy, they shared a general style with artists in Europe and America. Sargent and Steer lived near each other and were friends. They made common ground as the two most derided, but nevertheless noticed, Impressionists in London. If their kind of painting had not already been given a name in France, they might have been called the Chelsea School, since Whistler too had lived in this attractive old village beside the Thames in London.

THE VARIETY OF IMPRESSIONISM

It was the American art historian John Rewald who in the 1940s established the idea that there had been an inner core of Impressionists, a half dozen French painters who all knew each other and exhibited together in the 1870s in Paris. This grouping has only a limited validity, because it is not at all clear what should be described as the fundamental practice of Impressionism, and there were many small groups of artists at that time that came together for a few years, bound temporarily by shared aesthetic approach. Other artists exhibited alongside Rewald's group, and their art developed a variety of interests based on the art of the preceding years. Those precedents were carried forward in such a way that it misses the point to attempt to define a pure version of the style. Whistler was personally close to the French realist artists Alphonse

Legros and Henri Fantin-Latour and an admirer and near disciple of Gustave Courbet. What immediately links these pioneering artists in Paris was not so much their subjects or coloring or even aesthetic ambitions but their sheer skill in painting, in the sense of making an illusion on the canvas. Such an art was quickly learned by young artists who studied in Paris and was taken and developed in other countries. Since the demonstration by Norma Broude in the illustrations of the huge book she edited in 1990, *World Impressionism,* there have been many exhibitions of a wider kind of "Impressionism" in various countries, especially in America and Britain.

In all the varied practices of Impressionism what counted was painterly skill, because this was a daring way of making a picture from touches of color, in which there was no falling back to correction or to painstaking method. The illusion, which was everything, was risked in a touch and made evident through an accumulation of visible brushstrokes. This demanding technique remains one of the great appeals of this painting and can be enjoyed in all the pictures in this exhibition. For example, in his portrait or so-called portrait of the eight-year-old Cicely Alexander (cat. 4), the daughter of a London city banker, Whistler deliberately shows off that the picture is an arrangement of lines and paint as much as it is a portrait. At the edges of the picture the illusion falls apart into the separate bits of its construction, making all the more miraculous the appearance of the patient, young-in-old, posing figure. The colors are presented as if in their only pure form in nature, in the butterflies and flowers, and that it is all a design is emphasized by the severe right-angle in the paneling in the background, looking like an architect's T square. The design and color separately construct the standing figure. Her skin seems rounded and soft, but only just, so her face is almost transparent, and her childish complexion consists of canvas that the paint hardly covers. But it is the costume that is the picture, of which every element, especially the plumed hat, is shown in overlapping layers of material paint. The thin, stained underlying layers are covered by a quickly painted upper layer that makes up the pleats

and patterns, each applied with flowing, meandering brushstrokes.

Whistler used a new format of title for this painting, putting first the art, in terms of music and color: and then only second, after a colon, the particular instance. This he called *Harmony in Grey and Green: Miss Cicely Alexander.* It was extraordinary, and a seeming breach of decorum at that date, to suggest so openly that the artist's conception came before the character of the sitter. The critic George Moore described it correctly in 1893, appreciating its visual quality: "Truly, this picture seems to me the most beautiful in the world. . . . The portrait . . . enchants with the harmony of color, with the melody of composition. . . . This picture seems to exist principally in the seeing!"[1] Whistler, although an outstanding draftsman in his prints, made few drawings for his paintings and instead required prolonged posing for his portraits while he made up the picture on the canvas with the model before him. In a technical sense, the painting was the contrary of "academic," in that the artist's touch of paint had replaced skill in drawing as the fundamental means.

MODERN LIFE

Many recent historians of Impressionism have sought a link between this new structure of painting, which is an aesthetic and technical matter, with a new interest in common, everyday subjects for art and with a democratization of art in the enjoyment and collecting of pictures. This link is certainly elusive, and it is not the case that the Impressionists patented a certain kind of subject, even if the term is limited to a few artists. Much as they often chose to paint the Paris streets, so did other more conventional artists paint the streets of European and American cities. But it did seem that such a fundamental change in taste led also to a break in patronage, and institutions and connoisseurs like Henry Tate who were buying academic Victorian paintings usually—with a few exceptions—did not cultivate a liking for the Impressionists.

Whistler's new way of painting was not directed particularly at the recording of modern life, even if he did in pictures in this exhibition paint the river Thames in London, and

the docks at Valparaiso, and a fireworks display in Cremorne Gardens. The modernity of Sargent's society portraits, too, however indubitable, is rather ambiguous, since the implied association for the pictures is often to the old masters, whether through their scale or the deportment of the sitters or their evident wealth, as if they were the great patrons of the arts from the past. There is both a suggested continuity from the past and an acknowledgment of the present day within the personalities Sargent created. The most modern-looking of the pictures are the most brightly colored—Sargent's oil sketch of Monet painting and Steer's series of pictures of the beaches of East Anglia—but this is not due to their subjects. A picture like Sargent's of another artist at work is familiar enough in the old master section of an art gallery, and while popular sea-bathing enjoyed a revival for reasons of health the titles of Steer's paintings would have fitted easily alongside similar ones of conventional exhibits at the Royal Academy in the 1880s. The manner of the paintings was outrageous, but not the things that were being chosen to paint.

JAMES McNEILL WHISTLER

Whistler was a perfectionist, and idiosyncratic, and a showman, and took pains to display his art in exactly the way he wanted. The unusual titles he gave his pictures in themselves insisted on a certain kind of appreciation. He also published an account of his aesthetic principles, which he gave first in 1885 as a lecture before a public audience. It was advertised as an after-dinner event, as if a late play at a theater, by calling it "Mr. Whistler's 'Ten O'Clock'" (fig. 3). Artists had rarely given such a presentation of their ideas, but here, in a summary of his principles at the age of fifty, the Ten O'Clock Lecture proclaimed that the true artist (evidently Whistler himself) had no connection with his country or time: "The master stands in no relation to the moment at which he occurs—a monument of isolation—hinting at sadness—having no part in the progress of his fellow men."[2] This may be correctly reporting his attitude, however much it is nonsensical as history, but Whistler's own career was bipolar like this, seemingly international and

withdrawn out of time and country, yet also very clearly rooted in the places where he worked.

Born of American parents, and educated partly in America and partly abroad, he trained as an artist almost entirely in Paris in the late 1850s. He then lived between London and Paris, mostly in London, where he was usually thought of as American. He traveled easily between these cities, also spending long periods in Venice. He began his career as a printmaker, and what was extraordinary about his first triumph—a series of etchings primarily of the river Thames and the London docks—was the placing together of the simple and the complex in the drawing of the scenes. The intricate shipping and ragged wooden buildings of London were copied in detail,

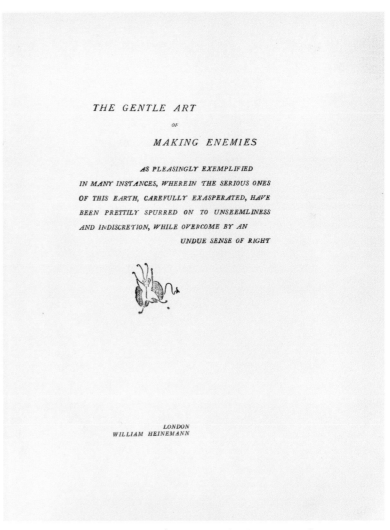

Fig. 3. Title page of Whistler, *The Gentle Art of Making Enemies,* 1890, which includes his lecture, "Mr. Whistler's 'Ten O'Clock.'" Tate. © Tate London, 2002

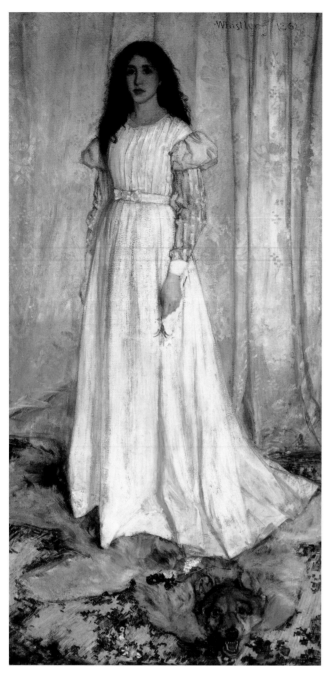

Fig. 4. James McNeill Whistler, American, 1834–1903. *Symphony in White, No. 1: The White Girl,* 1862. Oil on canvas; 83⅞ × 42½ in. (213 × 108 cm). National Gallery of Art, Washington, Harris Whittemore Collection. Photograph © 2002 Board of Trustees, National Gallery of Art, Washington, 1943.6.2

but alongside them were sketchy outlines and vacant spaces, with always a brilliant evocation of depth and receding space. Although his landscapes and portraits were never again detailed in such a straightforward way, his habit of seeing a local focus within areas of vacant texture remained essential to his painting. However painterly he became, both the tiny focus and the broad effect show always his amazing dexterity of hand: he was one of the most skillful users ever of pencil and brush.

THE COLOR WHITE

The *Symphony in White, No. 2: The Little White Girl* (to use its slightly later title; cat. 1) was shown in 1865 at the Royal Academy exhibition in London, where Whistler had already been sending prints and paintings for the previous six years. It divided critics, with many disliking it but with a few appreciating the beauty of its coloring. Whistler's biographers, his friends and printing assistants, the couple Joseph and Elizabeth Pennell, considered much later that this was "the most complete, the most perfect picture he ever painted."[3] It is a less extreme version of his earlier and larger portrait of the same model, his companion Jo Hiffernan, who was in that painting dressed more forcefully in white alone as the *Symphony in White, No. 1: The White Girl* (fig. 4). Whistler's admiration for Japanese style is overt in the Tate picture's ornaments—a painted fan, the azalea plant, a blue-and-white china vase, a pink china pot—and extends to the clear rectilinear design, which emphasizes the downward fall of the model's pose. But the picture's mood of reflection before a mirror is literary in an English way. Whistler so approved of a short poem that his friend Algernon Swinburne wrote about the picture that he had a copy of it written on gold-colored paper and attached to either side of the original frame. This poem hints mournfully at lost love, an uncertain future, the questioning by the woman of her reflection in the mirror, and the fragility of beauty as ephemeral as a flower.

It is difficult now to go back to recover the impact of such a picture in 1865. It was not just the separation of the colors, between the whites of the dress and the pinks of flowers and flesh, that was unusual, but also the

emphasis given to the color white in itself, which is stressed in the title. White was, in an uncertain way, a sign of purity or innocence, so there was a moral undercurrent, expressed ambiguously in terms of the mirror and flowers. This model, Jo, was well known for the coloring of her hair, which was described in a review of the picture as "flame yellow" (although Courbet had painted her with red hair). This coloring may now have become subdued as the paint has become more transparent, and it may originally have had a further radiance. The idea of painting in monochrome, in this large area of white, could only be expressive in contrast to a more conventional, darker coloring. At just this time Whistler and Edouard Manet were compared as the heirs of the French artist most famous as a colorist, Eugène Delacroix, in a group portrait by Fantin-Latour, *Homage to Delacroix* (fig. 5). It was then that Whistler began to concentrate on his vision of a single color and on the beautiful handling of pure paint, and he diverged from the direction that Manet was to continue with higher-keyed color.

The large and unfinished *Three Figures: Pink and Grey* (cat. 5) carries further Whistler's idea of a Japanese style and an evocation of a distinctive artistic life, creating a strange ideal of decorative adolescence, where unclothed children are looking after a flowering cherry tree in an indoor garden. The painting was an enlargement of one of a group of designs Whistler made for the decoration of a house in London, only one of which was completed. The Tate's painting is itself a recent recovery following a period of conservation (and the making of a new frame in Whistler's style). The oil sketches for this projected frieze, six paintings at the Freer Gallery of Art in Washington, D.C. (fig. 6), were carefully planned in separate groups of colors—blue and green, white and red, blue and pink—with this sketch originally based only on white, before becoming the *Pink and Grey* of the title.

THE "NOCTURNES"
But the furthest reaches toward monochrome, and one of Whistler's greatest achievements (and one of the prides of Tate Collections), are his pictures of the river Thames in London

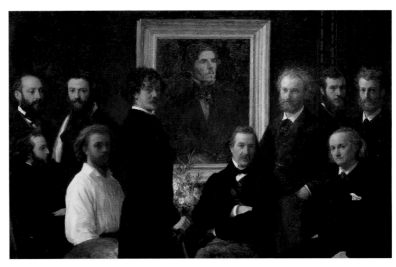

Fig. 5. Henri Fantin-Latour, French, 1836–1904. *Homage to Delacroix: Cordier, Duranty, Legros, Fantin-Latour, Whistler, Champfleury, Manet, Bracquemond, Baudelaire, A. de Balleroy*, 1864. Oil on canvas; 63 × 98⅜ in. (160 × 250 cm). Musée d'Orsay, Paris, France. Photo: Hervé Lewandowski, © Réunion des Musées Nationaux/Art Resource, NY

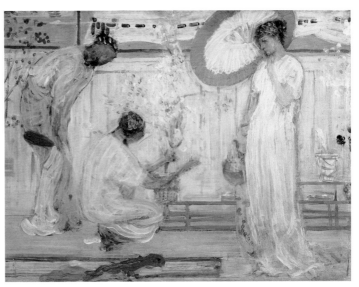

Fig. 6. James McNeill Whistler, American, 1834–1903. *The White Symphony: Three Girls*, 1868. Oil on millboard mounted on wood panel; 18¼ × 24¼ in. (46.4 × 61.6 cm). Freer Gallery of Art, Smithsonian Institution, Washington, D.C.: Gift of Charles Lang Freer, F1902.138

seen in the evening or by moonlight. They were a new type of landscape painting and represent a realignment of the relation between observation and artifice. His pictures of the harbor at Valparaiso in Chile were a prelude to this series. It is recorded that the *Crepuscule in Flesh Colour and Green: Valparaiso* was painted "at a single setting, having prepared his colors in advance" (cat. 2).[4] A fleet of sailing ships is seen at anchor outside the South American port, under a delicate pink and blue sky of the low sun at evening. The most distinctive colors are on a French tricolor, almost exactly at the center of the painting at the top of a mast. The detail that he had recorded in the early Thames etchings is superseded by a broad warmth of coloring, although at the right-hand edge Whistler has curiously drawn a cluster of masts in pencil over the oil paint, an unusual technique, and not successful when seen close. The painterly effect depends on the binding together of rich, liquid paint, which is why the picture had to be painted quickly from prepared colors.

The painting is also a historical monument in a different way, for the apparent disjunction between its tranquil beauty—emphasized by calling it the more romantic-sounding *Crepuscule* rather than *Sunset*—and the scene of modern warfare it depicts. Whistler had a military background, as his father had been an army major and he himself had been a cadet at West Point. His first job had been as a naval surveyor, making accurate etchings of the coastline from the sea. He had been personally untouched by the Civil War but in 1866 had traveled to Chile after joining a group selling military equipment during a brief war that pitted Chile, Bolivia, Ecuador, and Peru against Spain. The city of Valparaiso was all but destroyed in March that year by a Spanish naval bombardment, and the Tate's painting probably shows the allied French, British, and American fleets, which were neutral, leaving harbor before this attack began. There was a precedent for such a naval painting in some pictures by Manet, but this does seem an extreme case of the separation between the political contemporary man and the aloof artist in the same person. But perhaps this was Whistler's point—when the painting

was first exhibited in London the following year, the audience, seeing *Valparaiso 1866* written on the picture, would have known what that meant, but since then the story has been forgotten, leaving the picture to be admired for its inherent qualities, until recent research in London discovered the military history.

The challenge to visual memory that followed from separating observation from painting, by working in the studio directly in color without the use of drawings, was taken up by Whistler in the series of *Nocturnes,* of which thirty-one are known to exist. *Nocturne: Blue and Silver—Chelsea* (1871; cat. 3) was the first painted, and *Nocturne: Blue and Gold—Old Battersea Bridge* (ca. 1872–75; cat. 6) and *Nocturne: Black and Gold—The Fire Wheel* (1875; cat. 7) are part of the same series. Whistler was happy to explain his procedure: he could not paint by twilight, but in the evening he went out from his house beside the river in Chelsea to observe intensely a suitable view and keep it in his memory. The following day he would try to reproduce this in the studio, painting quickly in broad sweeps of prearranged color, held in some quantity (which he called a "sauce") in a kind of flat basin, applied to a canvas or panel flat on a table (fig. 7). If the sweep of color did not look right, he would wipe it off and start again. Whistler often first applied a dark ground color, gray or blue or green, so as to unite the overall effect of the thin layers of paint. *Blue and Silver—Chelsea* was painted on a wooden panel, and the brush marks are readily visible. The ground color was purely gray, and the brushed part is of two colors only;[5] the darker blue was applied first in two bands, to represent the foreground and the houses on the far bank of the river, and then a lighter blue was applied for the river and the sky. To depict so swiftly the profile of Chelsea Old Church and the other buildings depended on his graphic skill in making an outline, but the more important effect, here and in the other *Nocturnes,* was that of visualizing a sense of distance across the width of the river. "The barge, lights and the signature were applied on top of the sauce a little later, when the paint was partly dried and less easily disturbed. A stiff short-bristled brush was used for the barge, forcing paint to its outer edges

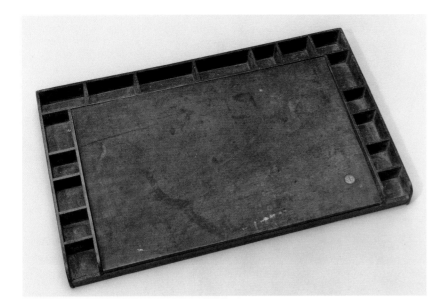

Fig. 7. Palette designed by James McNeill Whistler, made for the artist by A. R. Payne. Tate Archive, presented by Major General Fox-Pitt, grandson of Mr. Payne, 1980, TGA8022.15. © Tate London, 2002

to produce a very stylised result."[6] Such a fluid technique is reminiscent of printing from a plate, while etching and burnishing out or inking a monotype and sweeping away the colors, and there is an interaction in Whistler's art between printmaking and painting. There is a delicate point about the exact preservation of the colors, since that is what the whole painting depends on, and it is one that has a parallel with the painting of some of the abstract artists of the 1950s, such as Mark Rothko. With both kinds of artists, precise tints of colors and contrasts of color, which must have been extraordinarily beautiful at first, were made with stains of paint, but if the opacity of the paint alters, or if it becomes thicker through being varnished, then the effect is changed. It is alarming that the coloring stated in so many of Whistler's titles is unlike the present colors of the painting they are attached to. But Whistler often repainted his pictures and changed his titles, and the original titles are difficult to identify, so it is not always a question of whether some colors have changed in appearance.

Whistler v. Ruskin

It was this ease and limitation of technique that so offended the most admired art critic and moral philosopher in Britain of the time, the elderly John Ruskin, who adversely reviewed one of Whistler's *Nocturnes* of fireworks when it was displayed at the Grosvenor Gallery in 1877 (Berman, fig. 2). The Tate's *Fire Wheel*,

a very dark painting of fireworks at night, is similar to the picture that caused the scandal (cat. 7). Ruskin thought that the asking price of the picture was too much for something that had been painted so quickly, and was also rude about the artist. Whistler, who took pleasure in ridiculing his critics, sued him for libel, but although he won his case he was awarded only minimal financial damages and had to pay his own legal costs. The effect was disastrous. Whistler was soon declared bankrupt, had to sell his house and art collection, and lived for a period abroad. For about twenty years he had little money, few commissions, and made few large-scale paintings. Thus he was not able to provide the crucial link that he could have done between London and Paris. Worst of all was the loss of respect for modern art in Britain and the prevalent stereotyping of the avant-garde artist as tiresome and unable to tolerate criticism. It is arguable that the marginal position in Britain of contemporary art, which endured until about 1980, dates from this unnecessary lawsuit. The issue has remained alive, and in 1992 another outstanding American artist who lived in Chelsea in London, R. B. Kitaj, painted a revision of one of George Bellows's boxing paintings, but with Ruskin being knocked out of the ring (fig. 8). Ironically, within a few years Kitaj himself had left London, in part in response to hostile criticism.

Both Kitaj and Whistler were in a way practical historians of art, who reused the art of

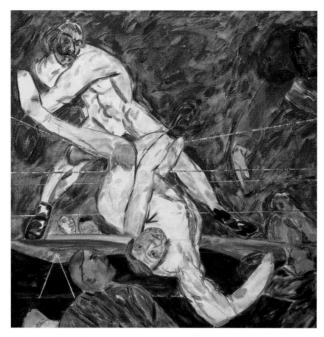

Fig. 8. R. B. Kitaj, American, b. 1932. *Whistler vs. Ruskin,*
1992. Oil on canvas; 60 × 60 in. (152.4 × 152.4 cm).
© R. B. Kitaj, courtesy, Marlborough Gallery, New York

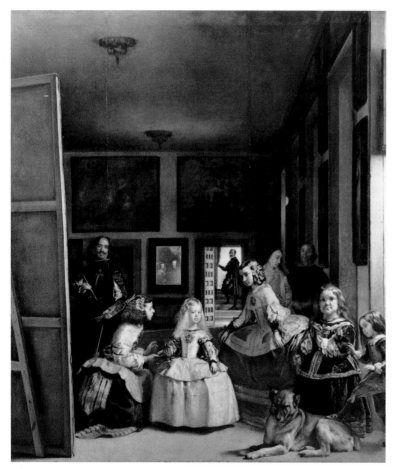

Fig. 9. Diego Velázquez, Spanish, 1599–1660. *Las Meninas,*
1656. Oil on canvas; 125¼ × 108¾ in. (318 × 276 cm).
Museo del Prado

the past for their work of the present. The
masterpiece of the Tate's Whistler collection
and perhaps, as George Moore thought, of
all his work, the portrait of Cicely Alexander,
is fundamentally his reanimation of the
seventeenth-century portraits by Velázquez
of the Spanish court. Whistler was a fanatic
admirer of Velázquez, and though he saw only
a few of his pictures—in exhibitions, in Lon-
don, and in private collections—he collected
photographs of them. Cicely Alexander was
set full length over an empty foreground, as
if for distant observation, looking like the
Infanta of *Las Meninas* (1656; fig. 9), or like
a characteristic pose of one of Velázquez's
aristocrats. Most important, Whistler con-
trived a balance of gray tones throughout the
portrait, where the diffuse lighting radiates
dimly from the subdued coloring, restrained,
beautiful, and surviving out of time.

The paintings by Whistler in the exhibition
precede everything by Sargent and Steer, and
he was their senior by twenty years, yet both
artists studied his work. Sargent too was de-
voted to the Spanish old masters, especially
Velázquez, whose paintings he copied in
Madrid. Steer probably tried, certainly with-
out success, to work with Whistler, and for a
time imitated his gray tonal paintings in scenes
of London and of the river. But both artists,
when in their twenties, also came to admire
the new paintings by Monet, with their radiant
rainbow coloring and speckled surface, and
they consciously took on this manner of paint-
ing and pushed it further themselves. Their
attitude to painting in the 1880s was an inter-
national one. They were comparable to many
Americans such as Maurice Prendergast, who
painted in London about 1890 (fig. 10), and
William Merritt Chase, whose brilliant and
direct landscape sketches were of the same time
(fig. 11).

JOHN SINGER SARGENT

Sargent was the child of expatriates and visited
America for the first time only in 1876 for
the Centennial. His father, a surgeon from
Boston, had retired early to live in Europe,
partly with the motive of looking after his wife
who was an invalid. Sargent was precocious
and studied art in Italy and Germany before

becoming a star pupil in Paris, passing his last examination for the Ecole des Beaux-Arts at the highest ever position for an American student. Within a few years he had exhibited paintings in Paris, London, New York, and Boston that transformed the current style of society portraiture and almost repaired the division between the avant-garde and the academy. Sargent was, in a sense, international, familiar with Europe and America, and it may be that his rootlessness contributed to his being able to provide what was wanted in such portraiture. He could avoid wrecking his depictions of others against the intrusion of his own national character, like a famous model of fashionable clothes today, who can show off whatever she is asked, while seeming to have no special character of her own.

In his early years in Paris, and for a while in London after he moved to Chelsea about 1886, Sargent conveyed an eccentricity and an elusive artfulness in some of his pictures that hinted bafflingly at a further relevance. This strangeness was seen only in the portraits and groups that he made for himself, not the commissions he received, but he was able to use his friends as models for his own purposes. Thus it was Sargent who approached a well-known American-born socialite in Paris, Madame Virginie Gautreau, and asked to paint her portrait, to be ready for exhibition at the annual spring Salon of 1884 (fig. 12). The Tate's version of this portrait is the artist's unfinished full-size copy, made probably by tracing from the original (cat. 8). The purpose of this is unknown but may have been to enable both sitter and artist to have the portrait, or it may have been to allow him some revision in the coloring. The project was abandoned when the exhibited portrait was mocked for overstepping social decorum, and he kept both pictures himself. This presentation is extremely peculiar—the unrelaxed pose with twisted neck and tensioned right arm—"her arm torqued as if she were about to spin the table like a roulette wheel"[7]—the overly pointed nose, the vast expanse of shoulder and bosom, the skin covered with makeup (and her hair, in the original, impregnated with metal dust). There seems an absence of genuine character, as if we were seeing her

Fig. 10. Maurice Brazil Prendergast, Canadian/American, 1858–1924. *Primrose Hill,* 1895–1900. Monotype with graphite, 7⅜ × 5⅝ in. (18.7 × 14.3 cm). Terra Foundation for the Arts, Daniel J. Terra Collection, 1992.98. Photograph courtesy of Terra Foundation for the Arts, Chicago

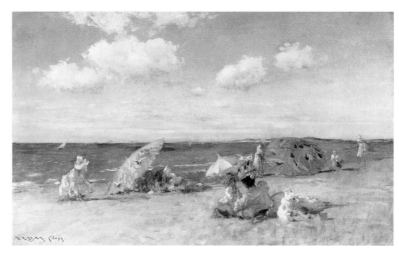

Fig. 11. William Merritt Chase, American, 1849–1916. *At the Seaside,* ca. 1892. Oil on canvas; 20 × 34 in. (50.8 × 86.4 cm). The Metropolitan Museum of Art, Bequest of Miss Adelaide Milton de Groot (1876–1967), 1967, 67.187.123

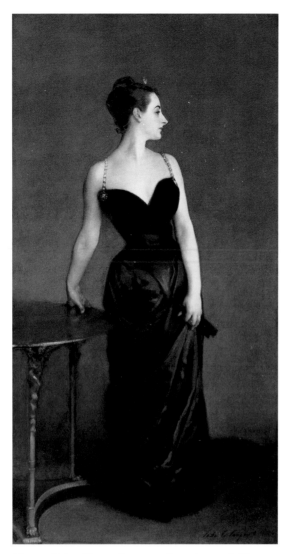

Fig. 12. John Singer Sargent, American, 1856–
1925. *Madame X (Madame Pierre Gautreau)*, 1883–84.
Oil on canvas; 82⅛ × 43¼ in. (208.6 × 109.9 cm).
The Metropolitan Museum of Art, Arthur Hoppock
Hearn Fund, 1916, 16.53

posing as a female Mephistopheles. Such
artfulness repeats the strategy of Whistler's
contemporary portraiture but gives it a more
disturbing character by the challenging sexu-
ality and solid presence of the figure. In com-
parison to Cicely Alexander, painted only
twelve years earlier, the license with which
both artists made use of their sitter is remark-
able, but Sargent makes the Whistler look like
a beautiful charade.

SARGENT'S IMPRESSIONISM

Sargent had always painted small oil sketches
as well as portraits, notably of local people in
the streets of Venice. When he spent several
summers in the English countryside he began
enthusiastically to sketch out-of-doors, turn-
ing to landscape and setting up his easel in the
fields. Such painting was then a fashion, but it
was also a deliberate change of his attitude, not
just in technique but in the whole routine of
painting—to make numerous small pictures, of
more or less equal value, instead of only three
or four major works each year. His sketch of
Monet painting out-of-doors in France dem-
onstrates both how much and how little he
wanted to take from the older artist (cat. 9),
whom he knew well at this time. Most impor-
tant was the heap of bright colors that seems
to dazzle from Monet's palette (p. 64, fig. 1),
colors Sargent was also to use in his sketches.
The picture is a demonstration of how to set
about painting in the Impressionist way, sit-
ting outside, without any drawings, and fin-
ishing the picture (apparently, but not in
fact the case) at one go. But Sargent's sketch
is an anecdote, as Monet's paintings were
not: it is small; it is not a commercial picture
(Sargent kept it himself and only exhibited it
ten years later); and he did not use color in
a structural way.

To go on from this and look for the
"Impressionist Portrait" is to some extent to
seek a self-contradiction, especially if the por-
trait in question were commissioned and had
to satisfy the sitter. An impression cannot be
shared, and a portrait has to be painted care-
fully over a number of sittings. But having
tried without success in practical terms to
paint portraits out-of-doors, Sargent relaxed
his straining after old masterly effects and

incorporated into his portraiture a newly tested skill in illusionism. His informal portrait of his friend Mrs. Frederick Barnard (cat. 10), painted in winter by oil light, has the directness of a sketch and shows off his skill in painting the extraordinary full shoulders and narrow sleeves of her unusual dress. The echo of Whistler's *Little White Girl* is probably coincidental, but the comparison points to Sargent's naturalism, which now lacks an undercurrent of Symbolism. That Sargent became so proficient was partly due to his aptitude for sketching in oils, which itself led to a separation of the painting from the portrayal. His power of recording became so dispassionate that the sitter can be seen acting the character of his or her theatrical arrangement. Both Mrs. Barnard and Mrs. Robert Harrison (the subject of another portrait painted soon after his move to Britain) were friends of Sargent, although their portraits were probably paid for. The red and white coloring of Mrs. Harrison's even more extraordinary gauze dress and open satin cloak was likely chosen to allow Sargent to restrict his palette in a way that reflected her own complexion throughout the picture (cat. 11). The application is delicate, using minute touches of thicker paint only on her discreet jewelry and suggesting a nervousness in her scuttling, elongated fingers, a gesture she cannot have held for more than a second. *Mrs. Harrison* was shown at the Royal Academy in 1886, an aristocratic picture presented in rooms that often showed the old masters, and *Mrs. Barnard* was sent in the same year to the first exhibition of a new artists' exhibiting society, the New English Art Club.

It was in these NEAC exhibitions, twice a year, that what was already at the time called "the Impressionist school"[8] in British art was first seen, and in due course weakened and dispersed. The critics were in no doubt who were the most extreme artists: "Mr. Steer is, however, certainly the most ultra member of the Club, the great pillar of which is Mr. J. S. Sargent, the portrait-painter." Critics objected that this art appeared to be French and not English, that the artists were just showing off their dexterity, and that they did not paint things that were beautiful and interesting—all points that were quite true,

but are now seen to be in their favor. Steer was indeed the more extreme of the two, and although he also painted portraits, the center of his production was a quantity of smallish landscapes, painted to be sold from gallery walls, and independent of commissions from the rich.

PHILIP WILSON STEER

Steer had been an art student in Paris, but his studies there had been rather limited, and his career really began on his return to London, and in imitation of Whistler. It is not known how well he knew Sargent, but since both men were reticent and belonged to different social groups they may not have been close—Sargent: American, fluent in French, with famous friends like Henry James and Robert Louis Stevenson and enjoying wealthy society; Steer: close to British artists like Walter Sickert and living modestly, rarely traveling abroad. Sargent knew the people he painted, and their portraits speak openly to the viewer, but the children and adults in Steer's landscapes and portraits often turn their backs or are observed without implicit contact.

Steer took Impressionism to the English seaside. No doubt he liked the contrast with his own childhood in inland Gloucestershire and with his airless passion for collecting ancient coins, but the holiday on the beach was anyway exciting as a newish vogue. Beach paintings (and holiday photographs) have become so common that it is difficult to remember that when day-to-day dress was so elaborate, going to the seaside in itself meant a welcome and undressed childish exuberance. Steer returned to the little port of Walberswick in Suffolk almost every year from 1884 to 1891. Then in his mid- and late twenties, with no family, he began his lifetime habit of taking lodgings outside London for a long summer, to draw and paint in the open air. At first he was interested in smoothly painted pictures of reflections from water, clearly modeled on Whistler's *Nocturnes*. The Tate has such an evening scene, *The Bridge* (cat. 27), which is comparable to Whistler's *Crepuscule* at Valparaiso of twenty years earlier, except that Steer, unusually for him, put a romantic couple in the foreground. When it was first exhibited

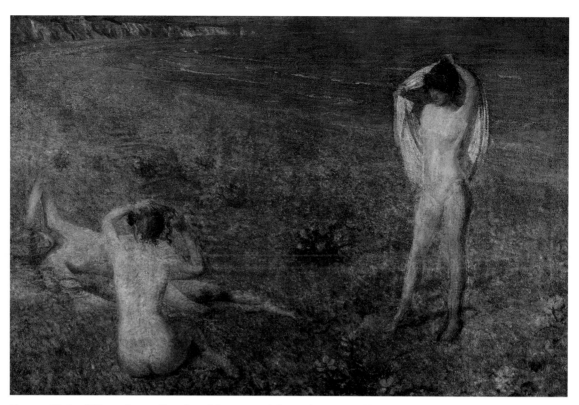

Fig. 13. Philip Wilson Steer, British, 1860–1942. *A Summer's Evening*, 1888.
Oil on canvas; 62⅝ × 90½ in. (159 × 230 cm). Private collection

in 1888 this modest picture was thought incompetent, although this may reflect the critics' earlier dismay a few weeks beforehand over Steer's large *A Summer's Evening* of three views in one painting of the same young girl, naked on a beach at sunset, in overall reddish colors (fig. 13)—his most ambitious painting, made over the same years as Georges Seurat's similar *Les Poseuses* (Barnes Foundation, Merion, Pa.).

The comparison made by critics in the press reviews of Steer was always with Whistler and Monet. The French Impressionists were generally known in London after an exhibition of 1883. Though in America the first large exhibition came slightly later, in 1886, the response there was much more positive, and it was reviews reprinted in the London press from American journals that gave the best introduction to the subject written in English. Thus the figure at the right of *The Bridge*, added late to the picture, corresponds to a report repeated from New York: "Another marked peculiarity of the Impressionists is the truncated composition, the placing in the foreground of the picture of fragments of figures and objects, half a ballet girl, for

instance. . . ."[9] (The cutoff ballet girl appeared in a picture by Edgar Degas.)

For a few years after 1888 Steer exhibited in London and abroad pictures that might be claimed as the most advanced in style ever in modern British art, allowing for the expectations of the moment. He had presumably admired the new Mediterranean pictures by Monet shown in London in April 1889, and he then repainted some of his beach scenes and continued to paint others. His colors were now intense, with strident red and blue, the surface of the pictures thick with furrowed paint, the drawing and detail fragmented. Steer prepared these pictures by scribbling rapidly in pencil in sketchbooks out-of-doors, and the paintings were made up graphically, drawn on the canvas after this practice on paper. Like Whistler's, his Walberswick drawings have a hesitant, dabbing suggestiveness, based on the sight of the figures, but without giving them a personality, vivifying them instead with his sudden notation of light and dark. They seem apparitions, with few outlines but a repertoire of calligraphic whirls and dashes, drawn with the point and side of

the pencil, as if he were recording by sight without looking at his paper.

Girls Running, Walberswick Pier shows the moment in the evening of the reddest sunlight and the longest shadows (cat. 34). It was painted over a bright red ground, which now shows through cracks in the paint, and all but one of the five girls, like so many of Steer's, have red hair. The two run toward the setting sun, toward three unseen figures whose shadows fall across the foreground. One of these shadows must be in the position of the artist (although it is ambiguous which way they are facing). Each girl, now, has two alternative positions for her lower arm, as the underpaint has shown through, so they partly hold hands and partly do not. The repetition, with only one girl looking at the artist and each of them perched on one black-stockinged leg, while an older girl behind them looks to the horizon, provides an unstated but weird poetic quality. This is not by chance, and the shapes of Steer's figures are often exceptionally odd-looking, and strikingly different from more conventional paintings of the beach by an artist such as Alfred Glendening (fig. 14). Steer's beach scenes are paralleled in some of the views of Long Island of the same time by the American Impressionists, and Chase particularly also showed off the sunlit, dazzling, time-free relaxation of girls on the beach, with a similar degree of bravura painting in primary colors (fig. 11). The later painting of the Bellport Regatta on Long Island by William Glackens at the Cheekwood Museum (fig. 15) takes up the same theme of reflected brilliance of light, here as a souvenir of sailing holidays. These American paintings, less overworked and more casual in perception, show up the more deliberate construction of Steer's pictures.

While his most striking paintings were these of girls on the beach, Steer still looked for portrait commissions, and at other times of the year he painted models, sometimes nude, in studio interiors. The episode of his Impressionism is made the more remarkable by the aftermath: his own infatuation for one of his young models (the subject of his tiny *Girl in a Blue Dress* [cat. 33], who was a former model for Whistler) and her reported refusal in 1895 of his offer of marriage. Steer furthermore

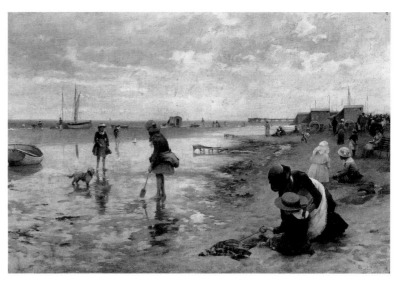

Fig. 14. Alfred Glendening, British, 1861–1907. *A Day at the Seaside,* 1886. Oil on canvas; 20 × 30 in. (50.8 × 76.2 cm). Private collection

Fig. 15. William Glackens, American, 1870–1938. *Bellport Regatta,* 1913. Oil on canvas; 25 × 30 in. (63.5 × 76.2 cm). Collection of Cheekwood Museum of Art, Nashville, Tennessee: Museum Purchase through the bequest of Anita Bevill McMichael Stallworth, 1994.9

moved on at about the time of this personal upset to link his naturalistic landscape painting to the examples of the British artists J.M.W. Turner and John Constable, searching for the archetypal view of the romantic vision of England. In retrospect, both these developments give even his more modern-looking pictures a feeling of unreality, or even nostalgia, as his most considered vision was toward the past—back through Monet, to Whistler, and to Constable—and his imagination leaned toward an immature relationship with childhood. But his later research into the tradition of landscape and the nude was widespread, inventive, and brilliantly painted, and still awaits appreciation in a thorough exhibition.

The Society Portrait

The greatest triumph of old master revival in Britain, from the 1890s on, was Sargent's large-scale portraiture. The demand already existed, supplied by a cluster of late Victorian portrait painters: John Everett Millais, Frank Dicksee, William Orchardson, Frederic Leighton, Edward Burne-Jones, Whistler, Val Prinsep, and others; and the examples to be matched were known through exhibitions and publications of both British artists, such as Joshua Reynolds and Thomas Gainsborough, and foreign, such as, especially, Anthony van Dyck. Sargent's success as a society portrait painter began in America, and he spent time in the 1890s in New York and Boston, hiring or borrowing studios to paint commissions. In the early 1890s British sitters were still nervous of his reputation, and his best portraits were of friends. From the time of his election as Associate of the Royal Academy in 1894 he was prodigiously active, until his self-proclaimed "retirement" from portraiture in 1908 at the age of fifty-two. The quality of his work varied, and at times he repeated poses or allowed his sitter to take attitudes that now seem ridiculous, especially in the case of the aristocracy (none of whom are represented in this exhibition). But many of them, even the most ordinary, have a compelling vivacity and often a pose that reveals at least an assumed character. Since many of his sitters were well known, the portraits have been used by historians and

biographers and have been taken to be characteristic of Edwardian Britain (1901–10). But the reality is never as clear, and the pictures themselves changed throughout this period. The better pictures are often of the people Sargent liked. He was shy on public occasions and remained a bachelor, living in a large Chelsea house with his mother and sister, but had a circle of close and loyal friends. He had no pupil, despite his work as a teacher at the Academy. The later continuation of portraiture in Britain by William Orpen and Augustus John abandoned the whole ethos behind his presentations, using a smaller format and matte technique in place of his satin glazes.

Sargent's portraits are about his own skill and his sitters' character. The latter may be purposely acting a role, but at least (in my experience) you learn rather more about his sitters in looking at their portrait for ten minutes than you do in talking to some contemporary celebrity for that time. Sargent asked if he could paint the well-known actress Ellen Terry, after he saw her on stage at the first night of her Lady Macbeth in 1889 (cat. 12). There was a connection, as he knew Alice Comyns Carr well, who designed Terry's stage costume, at this time of historical literalism in stage design. It was a unique chance for him to enjoy bizarre color clashes, in artificial light, of greens and deep blues, and to create a mock-terrifying femininity, as Lady Macbeth apparently crowns herself, like a Celtic Napoleon. He was also seizing a moment of mutually helpful publicity for actress and artist, and Sargent always chose his sitters well. His invention of the Terry portrait is typical of him in this elusive status between reality and fiction, and in his design, which is so simple in the single, grand gesture that the scale is effective. The picture was bought by the play's producer, Sir Henry Irving, and displayed in a public room in the theater where it was being performed, but it is not certain exactly when the massive frame, with its decoration of Celtic knots, was made for it.

This theatrical quality is equally present in Sargent's portrait of the artist W. Graham Robertson, in that he is dressed as a fashionable young man of the 1890s, holding a jade-handled cane, standing beside a huge poodle

with a pink collar, and posing self-consciously with an elegant hand on his hip (cat. 13). It was again Sargent who asked if he could paint him, and who insisted on the black coat. The picture was shown at the Royal Academy and acquired by Robertson himself. Sargent was worried that he might have been thought to have taken the design from Whistler's portrait of Count Robert de Montesquiou-Fezensac that was exhibited in the Salon in Paris shortly beforehand and had been painted in a nearby London studio (Berman, fig. 6). Montesquiou similarly holds a long cane and stands very thinly in black. There is a distinct similarity, though a marked difference in technique. The Whistler, slightly smaller, is properly titled *Arrangement in Black and Gold,* but the washes of color have separated cruelly, and the blacks (and most of it is black) have thickened under the varnish. Because of Sargent's painterly skill, it seems as if his portrait could have been set in any pose, except that he and the sitter had indeed chosen this appearance, true or false; they were both acting, and superbly. With Whistler's Montesquiou, it feels that his existence absolutely depends on this layering of paint as he emerges from within the darkness, and he could not have been any other way, and so was the more fragile, the more genuinely the dandy of the two. The coincidence has mostly to do with a certain fashion of dress and deportment, and Sargent may have been worried that his portrait might be thought to be mocking Whistler's, as a caricature, and he certainly would not have wanted to give offense.

THE BOSTON DECORATIONS
More totally his own invention alone, but again in this contrived character of contemporary life, were Sargent's complex and exciting paintings of figure groups, notably of Spanish gypsy dancers, which he tried to complete annually. He was given a historic opportunity by accepting in 1890 a commission to decorate the large staircase lobby of the new Public Library in Boston, designed by his friend Stanford White as an ambitious Renaissance palace, and one of the outstanding new buildings in America. The daunting subject of these paintings was to be a comparison of

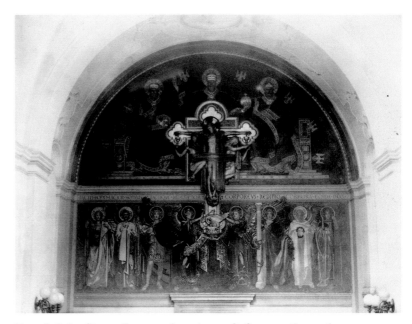

Fig. 16. John Singer Sargent, American, 1856–1925. *Dogma of the Redemption,* 1903. Oil on canvas, gilded relief of paper maché and plaster, gilded painted wood and metal; 11 × 22 ft. (3.3 × 6.7 m). Courtesy of the Trustees of the Boston Public Library

world religions and the triumph of Christianity (fig. 16). Even here it is not easy to encounter Sargent's personal beliefs, except that he took this on with great seriousness as a challenge, on the scale of the most famous of old master–painted interiors in Rome or Venice. He saw it as a continuation of such decorated chapels and studied as his point of departure Spanish and French medieval art. The *Preliminary Relief of the Crucifixion* is a one-third-size bronze cast of the model for the relief sculpture at the Boston Library and incorporates part of the cornice design of the building (cat. 14). From examples found in a book about stained glass in French cathedrals, he chose an unusual depiction of the Crucifixion and modeled figures of Adam and Eve collecting Christ's blood in chalices. They kneel and crouch in difficult poses and are bound to the crucified figure by a broad sash. Although he had no practice in making relief sculpture, Sargent was able to contrast the effect of the dead body beside these two living figures. The whole ensemble of the Boston Library occupied him for twenty years, and the earliest parts are fantastic Art Nouveau decorations of Moloch and Astarte, as Hell and Wisdom, popular, yet with a serious subject. One of his best and most surprising creations, these have been rather

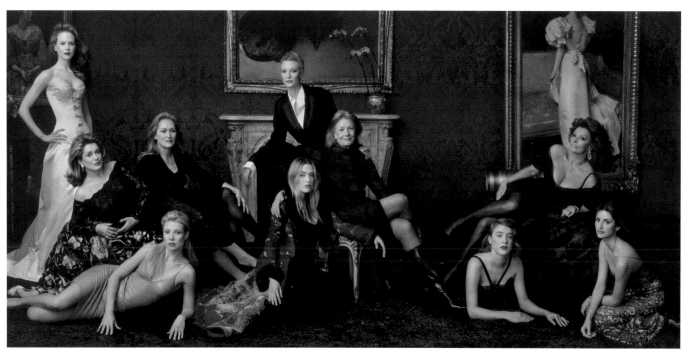

Fig. 17. Annie Leibovitz, American, b. 1949. Cover, Hollywood 2000, *Vanity Fair*, April 2000.
Left to right: Nicole Kidman, Catherine Deneuve, Meryl Streep, Gwyneth Paltrow, Cate Blanchett,
Kate Winslet, Vanessa Redgrave, Chloe Sevigny, Sophia Loren, Penelope Cruz. © 2001 Annie
Leibovitz/Contact Press Images. At right, John Singer Sargent, *Portrait of the Countess A. (Countess Clary Aldringen, 1867–1930)*, 1896; courtesy of Hirschl & Adler Galleries, Inc., New York

neglected while in need of cleaning and illumination, but the repair of his later murals at the Museum of Fine Arts, Boston has revealed them to be an immensely effective part of the classical revival of the 1920s. The Library decorations are one of the great works of religious art and a vital counterbalance to Sargent's production of society portraits.

THE SWAGGER PORTRAIT

The scale, richness, and shameless glamour of Sargent's portraiture at its peak in the early twentieth century remain astonishing. For a long time the pictures found an uneasy place in the modern art museum, because they seem out of their moment in art history, bound to a class of people who generally disliked modernism in art. But to be modern was not the point. This official neglect was at its deepest from the 1960s and was broken in part by the Tate Gallery's 1998 monographic exhibition of Sargent, shown also in Washington and Boston. The portraits are fascinating from the sitters' side, as devices to promote their self-awareness of social class, and it seems just possible to read distinctions between Americans,

British aristocrats, and British newcomers, although to do so without falling into the traps of snobbery is hazardous. It is appropriate that a recent group photograph of screen actresses for the cover of *Vanity Fair* magazine chose to include a Sargent portrait as decoration behind them (fig. 17). This is precisely the context for the Wertheimer and Hunter families and is much as they are seen now in the films of gilded age novels by Henry James. Sargent's rhetorical language was learned from the stage and from the artists of the grand manner, and his portraits found their place in the rooms of an earlier exhibition at the Tate Gallery of the Swagger Portrait (1992).

Sargent enjoyed testing his skill, in one way by contrasting different characters within members of a single family, an opportunity he was given most often with the commissions to paint the young sons and daughters of a family just before they began to marry and leave home. He was often asked to paint sisters. The Wertheimer family commissions were unique and finally amounted to twelve portraits, several of them groups of three people, painted between 1898 and 1908, each an independent

request. Asher Wertheimer was a dealer in art and antiques, with a large house in Mayfair, where in one room the portraits accumulated over those ten years. The series began with his own portrait (cat. 15) and that of his wife. The first one of his wife was rejected by the family and replaced by another commission, which perhaps led to the idea of replenishment and to the variety of the portraits as Sargent set them in different modes—one, of Almina, specifically after Van Dyck (cat. 20); one, of Helena ("Ena"), in the theatrical robes of a previous, male, sitter, as a joke (cat. 19); and the most famous of the pictures, of the sisters Ena and Betty, as a very marked contrast in their personalities (cat. 16). In this last pair, the illusionism of the paint is most brilliant and strained, as Sargent chose to include an open fan seen endon, gilt picture frames glinting in the darkness, an open hand painted with few touches, a gauze frill to the red velvet dress, and all this in addition to the contrasted complexions. This picture was extravagantly praised when it was shown at the Royal Academy in 1901.

The Wertheimers gave their paintings to the National Gallery in 1922, and in 1926, soon after Sargent's death, Mrs. Hunter gave the Tate the portrait of her daughters (cat. 17), "in memory of a great artist and a great friend." Mrs. Hunter spent conspicuously on entertainment at her houses in London and the country, and was a patron of Auguste Rodin as well as Sargent. Her friendship with Sargent was genuine to the extent that after her husband died in 1916 there was gossip that she and Sargent were to marry. He had already painted her portrait in 1898 when she asked him in 1902 for the large portrait of her three daughters. The size of the picture, on a canvas more than seven feet square, is significant, as it challenges both the production of such artists as Reynolds and Gainsborough and asserts the wealth of the patron who lived in houses large enough to accommodate it. The trio of young ladies perch on an ottoman, in fact in Sargent's studio in Chelsea, in front of a Japanese screen that appears in other portraits. There is an edgy relation between the evident authenticity of the scene, with its assertion of permanence by

the licensed comparison to eighteenth-century British portraits, and yet at the same time a precariousness, in their seeming eagerness to please, and in the absence in the picture of anything that was their own. If Madame Gautreau has been seen as spinning her little table, these sisters might be thought to be on a merry-go-round, with their dog about to be thrown off, and the circular movement becoming a Wheel of Fortune, reminding us of the uncertainty of the future. On the back of the canvas someone has subsequently written the sisters' names and the three people they married (and the husband's father in the case of one who had a title), as if to reassure posterity of their happy ending. The portrait has twice already been taken on a grand tour. Soon after it was painted it was shown at London's Royal Academy, in Paris, in Philadelphia, St. Louis, and New York; then in 1925, after Sargent's death, it was again taken to America, to Pittsburgh.

As he disengaged from portraiture, with difficulty, and as he had much wanted to for some time, Sargent returned to painting landscape. He was well-off and did not exhibit these pictures, which were his own self-motivated production. They were clearly a continuation of the Impressionist landscapes, with the difference that they were painted in watercolors. This work in part directed his summer holidays, as was the case for Steer. He traveled always with a party of friends and family, many of whom were also artists, especially in this convenient medium of watercolor which attracts the amateur. As with his portraits of Monet and other artists at work, he often again depicted this group at work painting. His watercolor of his sister Emily and their friend Eliza Wedgwood shows them painting, using the same equipment that he used himself (cat. 24). This was probably seen in the Alps, where they all stayed for long periods, sometimes going on to Italy and Venice. He liked to set difficulties for himself, with complex and varied subjects, and he liked also to keep the practicalities and social realities of modern life at a distance, as did many Edwardian tourists. The watercolors were compulsive and a relaxation, but in addition to their breathtaking skill they are remarkable for an original kind

of picturesque, a refinement of what it is that is a suitable subject for a picture. There is often an underlying nostalgia, perceptible in the sight of a group of the pictures where a historical building or statue is appreciated while yet overlaid by its surroundings, or is seen with a hesitant perception. The Venetian buildings are rarely shown architecturally complete, but cornered or abutting something else, or in contrast to foreground paraphernalia. But they are of his holidays and are often sympathetic or witty portraits of his friends, free of the pretensions of the oils. They are a coda to his life's work, and a spontaneous pleasure that contrasts with his major mural decorations at Boston.

The Tate is lucky to possess paintings by these three artists that fairly cover their range and fill the rooms at the Frist with some of their best work. At first one is struck by the diversity of the paintings: large and small, intimate and public, monochrome and brilliant. But the pictures' differences reflect the metropolitan society of late Victorian and Edwardian London over a period of more than fifty years. At the same time they illustrate the incorporation of what was at first an avant-garde style of specialist interest, Impressionism, into the overall appetite for art in London. The patrician accommodation of Sargent's huge portraits was the last flourishing of art on an old masterly scale and had a correspondingly grand moment in Edwardian architecture (as can be seen in the London residence of the royal family, Buckingham Palace, which was during this time enlarged and redecorated). This development came more or less to a full stop, and the huge portrait disappeared as a viable work of art. Although it was an eccentricity that could not last, especially in its quality as art rather than as empty social phenomenon, few of the best British artists of the next two generations did not incorporate portraiture as a serious aspect in their painting or sculpture.

Both Sargent and Steer left an unexpected bequest through their teaching. Sargent taught at the Royal Academy schools from 1894, where, for example, among his pupils in 1904 was the most remarkable painter of the Bloomsbury Group, Vanessa Bell, a pioneer of a new concordat with the avant-garde, who remembered his teaching positively. Steer had a wide, though indeterminate, influence on following generations through his teaching at the Slade School. There his pupils included some of the best of the next generation (Augustus John and William Orpen) and extended to the Cubists and Symbolists of about 1914 (such as David Bomberg and Stanley Spencer).

The diversity of appearance of these pictures, due partly to their function, is contradicted by the many similarities between various pairs of works, such as Whistler's and Sargent's full-length portraits; or between *Valparaiso* and *Mrs. Frederick Barnard* in terms of the handling of paint; or *Nocturne: Blue and Gold—Old Battersea Bridge* and Steer's *The Bridge* in their treatment of the same subject. The one intrusion, of French Impressionism, was a matter of style, an invention from Paris that came to the forefront through the work of Monet. This moment is reported from a summer in the mid-1880s, when Sargent saw Monet painting in brilliant colors a row of trees under an open sky, while sitting in a field and working with bright pigments piled onto his palette, but without drawings. Sargent promptly recorded this scene in the oil sketch in the present exhibition, which has the odd distinction of belonging to two genres at once: portrait and landscape. The exhibition at the Frist reveals how this intrusion, this brilliant invention that appealed to artists across Europe and America in the 1880s, was managed so much better than had been a similar opportunity for Whistler with his strikingly original *Nocturnes* in the 1870s. Whistler's *Falling Rocket* (like the *Fire Wheel* of this exhibition)—which so annoyed John Ruskin, who in turn infuriated Whistler and provoked him to become the least "gentle" of enemies—fell differently the second time. Sargent and Steer also found enemies in their critics, but they worked toward a compromise between confrontational modernism and a viable interface with their patrons, whether individual, in the case of portraits, or those who bought from exhibitions, in the case of landscapes. These paintings have been found to have an enduring appeal, and their onetime

strangeness has become a delight. Wilson Steer is unknown in America, yet he deserves his place alongside Whistler and Sargent. It is to be hoped that the audience at the Frist Center may enjoy this insight into the fashions of a hundred years ago, which then lured Americans to live in London, and may again be found attractive at the new gallery in Nashville.

NOTES

I am grateful for advice and assistance from Sandy Nairne, Joanne Bernstein, Robert Upstone, Susan Breen, Penny Whitehouse, John Anderson, Christopher Holden, Avis Berman, Mark Scala, Fronia W. Simpson, and Candace Adelson.

1. George Moore, *Modern Painting* (London: Walter Scott; New York: Charles Scribner's Sons, 1893), 11, 13.

2. Whistler's full title boasts that he has provoked his critics, "the serious ones," into making fools of themselves: *The Gentle Art of Making Enemies* (London: William Heinemann, 1890), 154–55.

3. Elizabeth Robins and Joseph Pennell, *The Life of James McNeill Whistler,* 5th rev. ed. (1908; London: William Heinemann, 1911), 41.

4. Arthur J. Eddy, *Recollections and Impressions of James A. McNeill Whistler* (Philadelphia and London: J. B. Lippincott, 1903), 23.

5. Stephen Hackney and Joyce Townsend, "James Abbot McNeill Whistler, *Nocturne in Blue-Green 1871,*" in *Paint and Purpose: A Study of Technique in British Art* (London: Tate Gallery Publishing, 1999), 152.

6. Hackney and Townsend 1999, 154.

7. Marc Simpson, *Uncanny Spectacle: The Public Career of the Young John Singer Sargent,* exh. cat. (New Haven and London: Yale University Press, 1997), 131.

8. "Art. The New English Art Club," *The Spectator,* April 16, 1887, 527.

9. Kate Flint, *Impressionists in England: The Critical Reception* (London: Routledge and Kegan Paul, 1984), 78, quoting Theodore Child, *Harper's New Monthly Magazine,* January 1887.

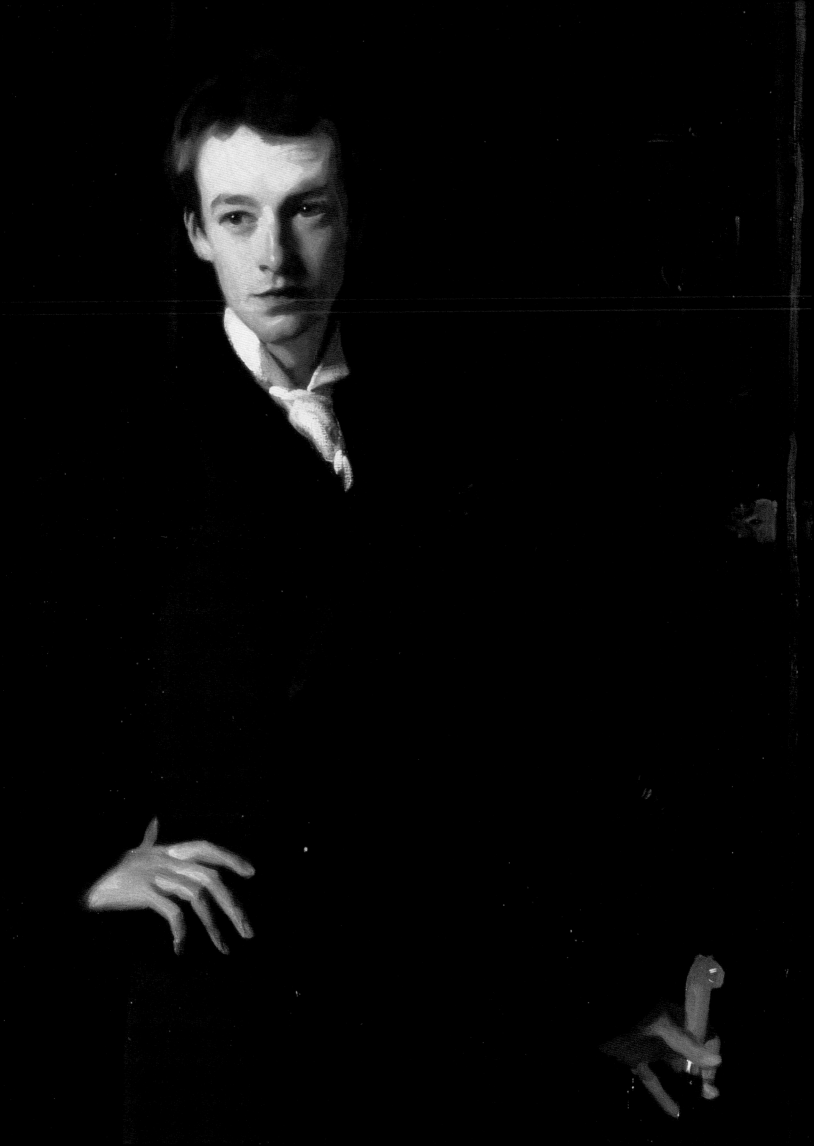

A Window on the Nineties

W. Graham Robertson and Aesthetic London

AVIS BERMAN

In 1934, when the author and critic James Agate lunched with W. Graham Robertson for the first time, the talk was so lively that he couldn't remember what he ate or drank. Robertson, he wrote in his diary, was "like a spar of the 'nineties washed up on the beach of today." Robertson regaled Agate and his companion with a story about John Spencer Stanhope (a disciple of the Pre-Raphaelite painter Edward Burne-Jones) and a particularly embarrassing canvas perpetrated by him. When Agate asked if Stanhope was dead, Robertson said, "Not more than usually." But was he actually dead? "Yes, of course," replied Robertson. "We all are!"[1]

For all of the "sly fun"[2] that Robertson poked at his new acquaintance, he counted on being forgotten. Indeed, he embraced oblivion by living intensely as a man of his time long after that time had passed. As Robertson hoped, to Agate and others he seemed a rare survivor of a legendary period, one of those slender young men (fig. 1) whom Oscar Wilde described as "exquisite Aeolian harps that play in the breeze of my matchless talk."[3] In the fin-de-siècle London of Aubrey Beardsley and Max Beerbohm, of Sargent, Whistler, and Steer, Robertson was a promising presence in the art and theater worlds. Even to pose forty years later as a ruin excavated from a particularly eccentric archaeological dig was central to the aesthetic credo of the 1890s, in which preposterous affectations and willful escapism contributed to the perfection of individual style and struck a blow against larger conventions. Robertson's snubbing of modern conveniences and technologies—as a retired country gentleman, he owned no car, lived without electricity, and railed against the movies to Agate—was a recognizable attribute of English individualism. The museums of Britain are indebted to the solidity and depth of that individualism in Robertson's record as a collector. First among the beneficiaries of his taste was the Tate Gallery.

The Robertson whom Agate met, a stout man usually "caped and hatted . . . in fabrics woven from the wool of his sheep dogs,"[4] was a many-faceted figure who occasionally tired of being pigeonholed as a nonentity. In 1936 he complained to a friend of being typecast in a recently published book of essays: "I appear in a later chapter as a benevolent and (as usual) modest old person. I'm so sick of my modesty —it's absurd to be modest at 70."[5] For the first forty years of his life, Robertson sustained a career as a painter, writer, collector, set and costume designer, and illustrator, all the while enjoying the adventure of an eclectic yet cohesive aesthetic education. Its course paralleled, intersected, and often encompassed tenets and values identified with Whistler, Sargent, and Steer at the height of their activity. As the subject of a prophetic Sargent portrait (cat. 13), a collector of Whistler and his contemporaries, and a co-exhibitor of Steer, Robertson was not only an acute observer but a representative reflection of the period. His preferences and idiosyncrasies are as characteristic as those of Beardsley, Henry James, Wilde, or Sargent. Robertson was a minor personality who glided through more celebrated lives, but he transcended being a mere link among acquaintances. He was an intelligent eye and mind in the grip of Pre-Raphaelitism on whom the struggle for Impressionism registered.

In truth, Agate postdated Robertson when he branded him the quintessential artifact of the 1890s. Because Robertson was precocious, his sensibility cannot be separated from the attitudes and atmosphere of the 1870s. Born in 1866 into a wealthy shipbuilding family

John Singer Sargent, *W. Graham Robertson,* (detail), 1894 (cat. 13)

Fig. 1. Frederick Hollyer, British, 1837–1933. *Walford Graham Robertson,* ca. 1890–93. Platinum print. By courtesy of the National Portrait Gallery, London, NPG P47

based in London, Robertson, an only child, grew up among adults. He was plunged into an artistic milieu as a small boy, and one that fed his sense of make-believe. "Pictures and plays have always been the two things that meant the most to me," he testified,[6] and he was stage-struck from the age of six and art-infatuated a few years later. By age ten, after visiting the studio of the illustrator and designer Walter Crane, he knew he wanted to be an artist, and a legacy left by his grandfather allowed him to purchase a painting by Crane.[7] Moreover, the notion of the theater as the meeting place for all the arts—writing, painting, acting, dance, design, and music—was a touchstone of his aesthetic. A governing event of Robertson's early art education, which anchored the aestheticism he espoused and embodied in the 1890s, commenced in 1877, when one of Victorian England's most famous art galleries was established.

In his autobiography, *Time Was,* Robertson stated that he attended the inaugural exhibition of the Grosvenor Gallery, which opened on May 1, 1877. This New Bond Street "palace

of art"[8] rapidly became an epicenter of progressive painting, and it was geared to the social and artistic upper crust. Devised at the outset as an antidote to the failings of the Royal Academy of Arts, which bowed too much to popular taste,[9] the gallery leaped into art and legal history within three months of opening its doors to the public. Among the Grosvenor's leading exhibitors was James McNeill Whistler, who was represented by eight paintings, including *Nocturne: Blue and Gold—Old Battersea Bridge* (cat. 6) and, most notoriously, *Nocturne in Black and Gold, the Falling Rocket* (fig. 2). The latter, the semiabstract depiction of fireworks exploding in a public amusement park in Chelsea, was executed in a daring manner. The bursting sparks of flame are represented by dynamic shots of paint spattered and dripped across the dark background of the canvas, yet such technical verve was lost on England's preeminent art critic. An appalled John Ruskin accused Whistler of "wilful imposture." He had "seen, and heard, much of cockney impudence before now; but never expected to hear a coxcomb ask two hundred guineas for flinging a pot of paint in the public's face."[10] Whistler sued Ruskin for libel, and both *The Falling Rocket* and *Nocturne: Blue and Gold—Old Battersea Bridge* were presented in evidence in November 1878, when the suit came to trial. Whistler won the case, but he was awarded only a farthing in damages, whereas he had hoped at worst to recoup some of the thousands of pounds the lawsuit had cost him. He went bankrupt and was forced to sell his house and possessions: creditors took control of a number of his paintings. In this way, he lost ownership of both *The Falling Rocket* and *Nocturne: Black and Gold—The Fire Wheel* (cat. 7) from 1878 until about 1891; Whistler was in the position of having to buy back his own paintings for a price plus interest.[11] George Bernard Shaw would later say that the painter's counsel should have appealed to philistine considerations and claimed damages based on commercial rather than artistic loss. "That sort of thing can be understood by lawyers, and he would have been awarded £1,000. But in talking about his Artistic Conscience he could only raise a farthing—that being all conscience is worth in the eyes of the Law."[12]

The controversy engendered by *Whistler v. Ruskin* has dominated twentieth-century perceptions of the Grosvenor Gallery, but to Victorian spectators the Grosvenor was a place to see a diverse group of artists, both advanced and conventional. Although Whistler continued to exhibit at the Grosvenor—*Nocturne: Blue and Silver—Chelsea* (cat. 3) and *Miss Cicely Alexander: Harmony in Grey and Green* (cat. 4), for example, were lent for the 1879 and the 1881 shows, respectively[13]—the gallery mainly promoted late manifestations of Pre-Raphaelitism as incarnated by Edward Burne-Jones, who was considered the star and mainstay of the establishment. Albert Moore, a painter known for his elaborately orchestrated compositions of women, influenced by Asian and Greek sources, also showed there, and in the 1880s Sargent and Steer made their debuts. These artists were connected, in one way or another, with the spread of the art-for-art's-sake doctrine, and it is no wonder that Gilbert and Sullivan, in their satire of the aesthetic craze, *Patience* (1881), immortalized the Grosvenor's fashionable premises as "the greenery-yallery Grosvenor Gallery."

Thus young Graham Robertson, who described attending Grosvenor Gallery exhibitions that first summer, as well as for the next two or three years, was in the thick of progressive art developments. "Thrilled by Burne-Jones, bewildered by Whistler," he wrote, "I arrived at the Albert Moores and, so to speak, sat down to rest among them."[14] At the age of eleven, Robertson could be excused for being mystified by Whistler, who was creating his most radical paintings and was linked to the French avant-garde. Burne-Jones, with his literary subject matter, was far more accessible. In his adult voice, Robertson made this distinction neatly, writing,

With Burne-Jones's pictures one can get a "book of the words." The inspiration is derived from a book. . . .

In Whistler's pictures of the river at dusk . . . the treatment is the result of a mood—the effect of the actual scene and hour upon the artist's mind, the vision is that of one who has seen something that man has looked at for centuries and never seen before.

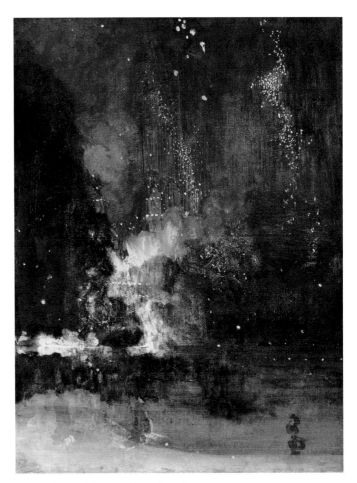

Fig. 2. James McNeill Whistler, American, 1834–1903. *Nocturne in Black and Gold, the Falling Rocket,* ca. 1875. Oil on wood panel; 23¾ × 18⅜ in. (60.3 × 46.7 cm). The Detroit Institute of Arts, Gift of Dexter M. Ferry, Jr., 46.309. Photograph © 2001 The Detroit Institute of Arts

Burne-Jones's art is the exquisite accompaniment to another's voice; Whistler's is the song itself.[15]

Albert Joseph Moore was a painter of female figures who lounged half-naked in rhythmically patterned interiors. Immersed in the pursuit of formal rather than narrative aspects of painting, he had a Japanese understanding of line and color, a sculptural understanding of drapery and movement, and a faultless sense of composition and paint handling. In the words of his biographer, Robyn Asleson, "the atmosphere of perfect repose and hedonistic sensualism combines with the element of beauty to provide a pointed contrast between the ideals of art and the realities of modern life."[16] Moreover, Moore was not an establishment painter. He was consistently denied membership in the Royal Academy,

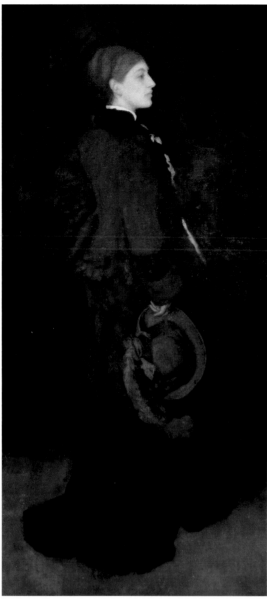

Fig. 3. James McNeill Whistler, American, 1834–
1903. *Arrangement in Brown and Black: Portrait of Miss Rosa
Corder,* 1875–78. Oil on canvas; 75¾ × 36⅜ in.
(192.4 × 92.4 cm). © The Frick Collection,
New York

and he was a loyal ally of Whistler—one of
only three men in London who were willing
to testify on his behalf during the Ruskin trial.
In 1879 Robertson was allowed to study with
Moore for a few months before returning to
school in 1880. Although the interlude was
brief, it set its seal on his artistic life.

Indeed, 1879 was arguably the annus mira-
bilis in the formation of Graham Robertson's
taste. "The Grosvenor Gallery was still the cave
of Aladdin, hung with jewels" that year, he
recalled, and chief among the treasures was the
portrait of Cicely Alexander, which he judged

"the masterpiece."[17] In addition, the two
Whistler paintings that Robertson would later
own—*Crepuscule in Flesh Colour and Green: Valparaiso*
(cat. 2) and *Arrangement in Brown and Black: Portrait
of Miss Rosa Corder* (fig. 3)—were in the exhibi-
tion. In 1879 Robertson also encountered the
two luminaries of the Lyceum Theatre. At age
thirteen, he saw *The Merchant of Venice,* starring
the Lyceum's actor-manager Sir Henry Irving
as Shylock and Ellen Terry as Portia—the role
that established her as "an actress of the first
rank."[18] After attending that performance,
Robertson was determined to dwell among
artists and actors. He worshiped actresses,
with Terry the presiding divinity. As a child,
Robertson paid homage from afar, but as a
wealthy and mature man who could offer
advice, sympathy, and generous hospitality,
he was admitted to the inner councils of Terry
(fig. 4), Sarah Bernhardt, and Mrs. Patrick
Campbell—all of whom he painted. He went
on to befriend the major stage personalities
of his time, including Lilllie Langtry, Gerald
du Maurier, Arthur Wing Pinero, Herbert
Beerbohm Tree, James M. Barrie, Alfred
Sutro, Alfred Lunt, Lynn Fontanne, Noël
Coward, Alexander Woollcott, Laurence
Olivier, Vivien Leigh, Terence Rattigan, and
Michael Redgrave. In 1926, he zeroed in on
Terry's great-nephew, a "conscientious" new-
comer whom he predicted "ought to go far."[19]
This green boy was John Gielgud.[20]

The force unseen but intensely felt in both
the Grosvenor Gallery and Robertson's youth-
ful universe was the poet and painter Dante
Gabriel Rossetti. The most charismatic mem-
ber of the original Pre-Raphaelite Brother-
hood, he lived in seclusion and refused the
Grosvenor's entreaties to exhibit. As Joseph
Comyns Carr, one of the gallery's directors,
wrote, "In the seventies, when I first became
actively engaged in the study of painting, the
stirring spirit of English Art still throbbed in
response to the message that had been deliv-
ered by the Pre-Raphaelite Brotherhood more
than twenty years before."[21] Robertson never
met Rossetti, though his art, which also in-
spired Burne-Jones in all he did and the
Whistler of *The Little White Girl: Symphony in White,
No. 2* (cat. 1), acted on him too "as a spark to
tinder, setting light to the imagination."[22]

And his mind remained fired by it. As late as 1943, Robertson would proclaim that Rossetti remained one of the "idols" of his house.[23]

With such admiration for Rossetti as preamble, Robertson was receptive to another consuming experience. In 1883, when he was seventeen, he happened on a biography of William Blake, the visionary writer and artist. A fervent enthusiasm was born, one consistent with his aesthetic lineage. At the time, Blake was not a revered or even well-known figure, but he had been championed by Rossetti and later by Burne-Jones, who embraced him as a precursor. Rossetti, who helped to reestablish Blake's place in the history of English culture, saw the older man as a direct intellectual ancestor. Both were poet-painters, both oeuvres were informed by Dante Alighieri, and both were passionate about political liberty. Concerning painting, Rossetti would write that Blake's "original and prismatic system of colour" was the "forerunner of a style

Fig. 5. William Blake, British, 1757–1827. *Newton*, 1795/ca. 1805. Color print finished in ink and watercolor on paper; 18⅛ × 23⅝ in. (46 × 60 cm). Tate, presented by W. Graham Robertson, 1939, N05058. © Tate London, 2002

Fig. 4. W. Graham Robertson, British, 1866–1948. *Dame Alice Ellen Terry*, 1922. Oil on canvas; 47 × 29 in. (119.4 × 73.7 cm). By courtesy of the National Portrait Gallery, London, NPG 3132

of execution now characterizing a whole new section of the English School," meaning, of course, the Pre-Raphaelite movement that Rossetti led.[24] In the 1860s Blake accounted for the friendship between Rossetti and Alexander Gilchrist, who was working on the biography of Blake that Robertson so fortuitously discovered twenty years later. As he neared completion of the manuscript in 1861, Gilchrist died of scarlet fever, and Rossetti stepped in to finish the book anonymously. The first edition appeared in 1863 and a second in 1880.

By the age of twenty, Robertson was an established Blake collector, in possession of forty drawings. He would succeed in amassing the largest and most important holdings of Blake drawings, paintings, and watercolors in private hands, adding about another hundred works to his collection. On the basis of such a collection, Robertson could look ahead to the 1890s and glance backward at Blake and trace a continuity. Blake's individualism played against the opportunism of the Royal Academy, which had vexed him as much in his day as it did Rossetti, Moore, and Whistler in theirs. Blake also provided Robertson with a model that defied utilitarianism and the coming modern age. One of Robertson's finest

Fig. 6. James McNeill Whistler, American, 1834–1903. *Arrangement in Black and Gold: Robert, Comte de Montesquiou-Fezensac,* 1891–92. Oil on canvas; 82⅛ × 36⅛ in. (208.6 × 91.8 cm). © The Frick Collection, New York

Blakes was *Newton* (fig. 5), an ambitious mono-print from 1795. Blake distrusted Sir Isaac Newton as a threat to the imagination for his single-minded pursuit of the deadly rational. The scientist's calculations symbolized an earthbound mental state. Concurring with his hero's attitude, Robertson commented on the print,

His *single vision* is intent upon solving some problem which needs no solution; his . . . face . . . is turned resolutely earthwards. . . . The great rock upon which he sits is covered with thick lichenous vegeta-tion, and is as a symbol of his mind—choked with endless minutiae . . . pale flowers of thought that have never looked upon the spiritual Sun.[25]

In 1884 Robertson's father, Graham Moore Robertson, died, removing the primary oppo-sition to the boy's becoming an artist. About this time he changed his given name from Graham Walford Robertson to W. Graham Robertson—because he, who already hated machinery,[26] "disliked sharing his initials with the Great Western Railway."[27] His mother excused him from university and together— Robertson would live with his mother until her death in 1907—they escaped from the strictures of their domestic environment, "which was pictureless, save for the inevitable Landseer engravings, without the aid of which a respectable Bayswater family could hardly have been expected to eat its dinner."[28] Shortly after Graham Moore Robertson's death, mother and son decamped for a year in France, where a more worldly artistic and literary education was available.

In Paris Robertson was taken up by Count Robert de Montesquiou-Fezensac (fig. 6), a poet, aesthete, and collector with an ancient French pedigree, but known today as the inspi-ration for two fictional characters, one per-fumed with period atmosphere and the other immortal. He was the model for Des Esseintes, the excruciatingly sensitive protagonist of J.-K. Huysmans's decadent novel *Against Nature* (1884), and the inspiration for baron de Charlus in Marcel Proust's *Remembrance of Things Past.* Montesquiou's encounter with Proust was still in the future when Robertson met him, but he tutored him in art and avant-garde lit-erature. Montesquiou's example—a tall, thin

man who looked like a greyhound and had a gray-walled room (necessitating him to ransack Paris weekly for gray flowers)—illustrated the art-for-art's-sake tenet that style was the man.

Just as Robertson was repatriating to London, Montesquiou became an admirer of Whistler. In 1885 Henry James had a dinner to which he invited Montesquiou and Whistler, and the two dandies charmed each other. The count's first letter to Robertson mentions Whistler and his desire to see the Peacock Room, the dining room Whistler had transformed with a continuous frieze of turquoise-breasted birds, their tails cascading into showers of silver and gold, in the Kensington town house of the collector and industrialist Frederick Leyland.[29] In a later letter, Montesquiou, who addressed him as "Cher Grah-ami,"[30] asked Robertson if he were familiar with Whistler's aesthetic propositions. Yet Montesquiou was not alone in readying Robertson for Whistler. Between 1885 and 1887 Robertson recommenced studying painting with Albert Moore, Whistler's staunch friend. The result, said Robertson, was that he "had been brought by Albert Moore in the knowledge and love of Whistler."[31] During this period of greatest closeness to Moore, Robertson purchased *The Toilette* (fig. 7), an oil of a diaphanously gowned woman in an opulent architectural setting.[32]

Robertson emerged from Moore's studio as a skillful painter of Pre-Raphaelite tendencies with a specialty in portraiture. He began his exhibition career at the New Gallery, a firm opened in 1888 by two former employees of the Grosvenor Gallery. The New Gallery also poached the Grosvenor's star, Burne-Jones, and thus the artists in his firmament were welcome. As Comyns Carr, one of the New Gallery's founders and the writer who had described the soul of English art in the 1870s as throbbing to Pre-Raphaelite drums, would conclude, "We did not, perhaps, then quite realize that the revolution, so far as they were concerned, was already complete."[33] (The Grosvenor itself would fold in 1890, a victim of changing tastes and pinched finances.)

Robertson first appeared at the New Gallery in 1889 with a small sketch of Sarah Bernhardt; his twin ardors for painting and the stage had

Fig. 7. Albert Moore, British, 1841–1893. *The Toilette,* 1886. Oil on canvas; 16½ × 9¼ in. (41.9 × 23.5 cm). Tate, bequeathed by W. Graham Robertson, 1948, NO5876. © Tate London, 2002

coalesced. He showed at the New Gallery almost annually for the next twenty years, and his most successful contributions were portraits of actors and actresses. Between 1891 and 1899 Robertson was also a regular exhibitor at the New English Art Club, an artists' society founded in 1886 to challenge the supremacy of the Royal Academy's hanging and selection policies. Among the outstanding early members were the American expatriate John Singer Sargent and the leaders of the coming generation of advanced British artists—Walter Sickert and Philip Wilson Steer. All three were allied in some way with Impressionism and Whistler. Indeed, Steer, six years Robertson's senior, had a similar reaction to the epochal Grosvenor Gallery show of 1877, where he first encountered Whistler's *Nocturnes.*

He thought that "they seemed too misty, the figures appeared as though they were in a fog. But there was something very good about them."[34] Steer, like Robertson, had lived and worked in France in the early 1880s, and he too moved back to London in 1885. He exhibited at the Grosvenor that year, but when the New English Art Club came into being a year later, he divided his allegiance. But he sent canvases to the Grosvenor through 1889, including *The Bridge* (cat. 27).[35] In 1891, when Robertson made his New English debut, Steer showed *Mrs. Cyprian Williams and Her Two Little Girls* (cat. 32); when they were fellow exhibitors a year later, Steer lent *Boulogne Sands* (cat. 31) and *A Procession of Yachts* (cat. 35).[36]

Whereas Steer was someone Robertson would have seen out of the corner of his eye at prominent exhibition venues, John Singer Sargent was a matter of central focus. Sargent was a voluntarily displaced Yankee then on the bohemian fringes of London and Paris because of an exhibition *succès de scandale*. Just as Whistler had first earned notoriety for showing *Symphony in White, No. 1: The White Girl* (Jenkins, fig. 4) at the landmark Salon des Refusés in 1863, Sargent became equally execrated and internationally noticed at the Salon of 1884 for *Madame X (Madame Pierre Gautreau)* (Jenkins, fig. 12), his erotically charged silhouette of the black-clad, lilac-skinned professional beauty, Virginie Avegno Gautreau. Because his career seemed shipwrecked after the clamor at the Salon, Sargent was persuaded by Henry James to settle in London, where he had exhibited at the Grosvenor in 1882, 1884, and 1886. Sponsored by James, Sargent circulated among artists, writers, actors, and the occasional industrialist; his associations of this period are documented in his acute portraits of Vernon Lee (1881; Tate Gallery), Robert Louis Stevenson (1887; Taft Museum, Cincinnati), and Edmund Gosse (1886; National Portrait Gallery, London).

If nothing else, Sargent won Robertson's approbation with *Ellen Terry as Lady Macbeth* (cat. 12). By 1889 Terry was a cherished friend and a frequent correspondent, and Robertson was her confidant, nursemaid, and host. As Lady Macbeth, appearing in a green and purple gown embossed with iridescent beetle's wings that was designed by Alice Comyns Carr, the wife of the New Gallery's cofounder, Terry crowns herself queen. (Oscar Wilde had a great deal of fun with the extravagant costume Terry wore for a drama set in primitive Scotland and in which Sargent luxuriated. Robertson recalled Wilde's remarking about the production: "Judging from the banquet, Lady Macbeth seems an economical housekeeper and evidently patronises local industries for her husband's clothes and the servants' liveries, but she takes care to do all her own shopping in Byzantium."[37])

As an actor, woman, and portrait subject, Terry is a heroine alone, seizing and emanating power. At first, Sargent sketched Lady Macbeth among other ladies of her court, but then he changed his mind, "discard[ing] pageantry for the grand upward thrust of the single figure."[38] Terry was struck by the psychological clarity of the painting, pleased that "Sargent saw . . . and in his picture is all that I meant to do."[39] Sargent exhibited this imperial portrait at the New Gallery, and Henry Irving became its first owner. He hung it in the Lyceum for audiences to venerate. The emotional intensity of Sargent's interpretation is tacitly reinforced by a watercolor sketch Robertson made of Terry in the same costume. In his idealized interpretation, the actress, then forty-two years old, looks like a sugary ingenue wafting about in Lincoln green and bound for a walk in Sherwood Forest,[40] rather than the scheming tactician of Shakespeare's play. But if Robertson adopted Burne-Jones's style, he had moved beyond his avatar's aesthetic prejudices—Burne-Jones despised Sargent's painting,[41] whereas Robertson could appreciate its theatricality.

Robertson also comprehended the blazing artificiality of the picture. The objectification of the body that Sargent had taken to a zenith in *Madame X* is displayed again in the portrait of the magenta-haired Terry. He painted what he saw before him, the actress straining to transfigure herself into a literary conception, a living art object, just as he strained to shape a breathing human being into an aesthetic image of introspection and self-defining performance composed from opposing rhythms, bold brushstrokes, and radiant surfaces. As a

rising painter and designer and a discerning collector, Robertson was primed to enter the 1890s as an exquisite of the period, a sidewalk saunterer who punctured his foes with repartee and aphorism. As a writer, Robertson displayed a vein of wit and paradox worthy of Wilde, whom he met in 1887. In *Time Was,* he produced epigrams that were pure Oscar, as when he noted, "I have a great regard for the truth, so much so that I only produce it upon special occasions."[42] When the two men met, Wilde was not yet the conquering playwright, but they shared a passion for art and theater, as well as an adulation of Terry. Wilde lived on Tite Street, directly across from Sargent's studio, and he told Robertson, "The street," said Wilde, "that on a wet and dreary morning has vouchsafed the vision of Lady Macbeth in full regalia magnificently seated in a four-wheeler can never again be as other streets: it must always be full of possibilities."[43] Nor did it hurt that Robertson was a slim, polished young man. (Judging from the clues in his surviving correspondence, it appears that Robertson was a discreet homosexual who had a public existence as a mother-burdened heterosexual bachelor.) On one occasion, Wilde wrote seductively to Robertson, while retaining his guise of the high priest of aestheticism:

Thank you so much for the drawings. They are a real source of delight to me. By the time you return I hope to have finished the story. I wish I could draw like you, for I like lines better than words, and colours more than sentences.

However, I console myself by trying now and then to put "The Universe" into a Sonnet.

Some day you must do a design of the Sonnet: a young man looking into a strange crystal that mirrors all the world: poetry should be like a crystal, it should make life more beautiful and less real. I am sorry you are going away, but your narcissus keeps you in my memory.

And, thinking Robertson's address too prosaic for his personality, Wilde objected,

Do you really live at Sandhills, Witley? Surely not Sandhills!

You are made for olive-groves, and for meadows starred with white narcissi. I am sure this letter will be returned to me by the post office.[44]

It is not recorded if Robertson took the bait, but when *The Picture of Dorian Gray* was published in 1890, Wilde admonished him, "Graham, the book was not written for you, and I hope you will not read it."[45] However, Robertson was trusted enough to be told to attend the opening night of *Lady Windemere's Fan* wearing a green carnation in his buttonhole, which marked him as one of Wilde's entourage and hinted, Wilde hoped, at a mysterious fraternity of decadents.[46] Soon after, when Wilde began to stage *Salome* with Sarah Bernhardt in the title role, Robertson was asked to design the actress's costume.

In April 1890 Charles Augustus Howell, one of London's arch con-men, died in debt. Successively friend, secretary, and agent to Ruskin, Burne-Jones, Rossetti, and Whistler, Howell entered each new business relationship as a faithful helper and ended it as an expelled thief when discovered embezzling his employers out of their own possessions. (No doubt Howell's rascally doings as well as Whistler's own extravagance contributed to the artist's financial collapse in 1879; Howell was very much in attendance then, ostensibly fending off creditors but actually pocketing pounds, pence, and pictures.) Terry alerted Robertson to the auction of Howell's effects, and he made bids so low that he did not expect to come away with anything, but the next day he was awarded two outstanding Whistler canvases—*Crepuscule in Flesh Colour and Green: Valparaiso,* bought for £126, and *Arrangement in Brown and Black: Portrait of Miss Rosa Corder,* which fetched £241.10.[47]

Corder, a painter who had been one of Howell's mistresses and bore a daughter by him,[48] posed to Whistler for a monochromatic portrait. Dressed in black street clothes and profiled against a dark background, she exudes "a beautiful stillness" and strength.[49] The seascape of Valparaiso harbor, which Robertson summarized as a "dream of opaline dusk falling on phantom ships becalmed in an enchanted sea,"[50] prefigured Impressionism in its fluid execution and focus on momentary conditions of light, air, and climate. Spare in

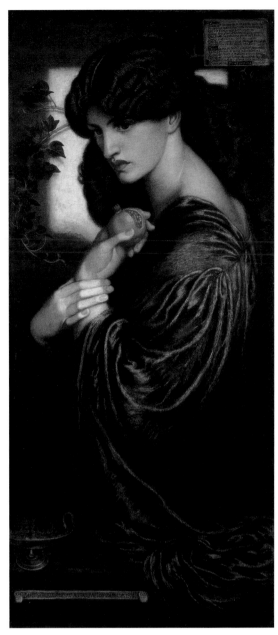

Fig. 8. Dante Gabriel Rossetti, British, 1828–
1882. *Proserpine*, 1874. Oil on canvas; 49¼ × 24 in.
(125.1 × 61 cm). Tate, presented by W. Graham
Robertson, 1940, N05064. © Tate London, 2002

outline, Whistler's seascape is a hazy, poetic
rendering of a fleeting moment. The artist
had learned how to render twilight, that indis-
tinct time when daylight fades and the night
steals over the earth. The foreground and
background are blended, and outlines melt
away. Whistler's thin, liquid layers telegraph
the translucency of sky, sea, clouds, and ships,
and, as with the portrait of Rosa Corder, the
subtle differences in substance and space come
on the viewer gently and gradually. *Crepuscule in*

Flesh Colour and Green was perhaps the closest to
avant-garde painting that Robertson ventured
as a collector, and it is revealing that he would
describe the work in the language of fantasy.
But by 1890 Whistler's pared-down approach,
touched by Japanese simplicity, had long been
accepted by younger artists, even to someone
as steeped as Robertson in a detailed Pre-
Raphaelite style.

Whistler had no idea of Robertson's
existence before the Howell sale. But he was
curious about a stranger who would buy two
pictures—no museum had yet purchased any
of his oils—and he asked "to know the collec-
tor who so far ventures to brave popular preju-
dice in this country."[51] Whistler arranged to
call, and Robertson trembled at the prospect
of entertaining the fearsome artist who prided
himself on his legions of enemies. But when
he could tear himself away from the sight of
his canvases from which he had been so long
estranged, Whistler was all charm and courtesy.
Robertson, who remained on good terms with
Whistler, was never a victim of his malice.

In 1892 Frederick Leyland, the patron of
the Peacock Room, died. His paintings went
on the block, giving Robertson the oppor-
tunity to buy the most important of the four
works by Rossetti that he would acquire. Ley-
land had owned *Proserpine* (fig. 8), a subject
that had obsessed Rossetti. The myth symbol-
ized his own frustrated relationship with Jane
Morris, who posed as Proserpina holding a
pomegranate. It also encapsulated the quin-
tessential Pre-Raphaelite motif of unrequited
love for a tantalizing woman in the guise of a
goddess, with pictorial tensions arising from
the uneasy union of spiritual ideals and sensu-
ous perceptions. Robertson bought *Proserpine*
at the Leyland sale in May 1892 for £567; he
was already the possessor of a pastel of Jane
Morris done in about 1876, which he bought
in May 1888 for just over £51.[52]

In the wake of a breakthrough public and
critical success that Sargent scored with his
lavish portrait *Lady Agnew of Lochnaw* (1892;
National Gallery of Scotland, Edinburgh), all
lavender and cream, Robertson commissioned
Sargent to paint a portrait of his mother,
Marion Greatorex Robertson (fig. 9). The

likeness of Mrs. Robertson, however, did not match up to that of Lady Agnew. Robertson squarely admitted that the painting was not what it might have been because his mother was "a bad sitter," loath to "'sit still and be stared at.'" How could Sargent capture a genuine self during the sittings, wondered Robertson, if "he never saw it."[53] In contrast to Mrs. Robertson's resistance was the attitude of the Wertheimer family, of whom Sargent painted twelve portraits. In his eponymous portrait (cat. 15), Asher Wertheimer did not flinch from Sargent's gaze, and in *Ena and Betty, Daughters of Asher and Mrs. Wertheimer* (cat. 16), the young women posing for the artist collaborate with him easily. Sargent did not have to infuse his subjects with vitality. On their own, they stroll out of the frame toward the viewer with audacious sensuality, and upper- and upper-middle class Britons attributed their animation to Jewish crassness. Both the Wertheimers and Sargent were targets of snobbish disapproval over these commissions. Toward the end of her life, and perhaps still resentful of her bland portrait, Marion Robertson lashed out at the artist. In a letter to her son about one of her friends currently sitting for Sargent, she wrote, "I don't think he will make a good Picture of her—he is more successful with his Jews and Jewesses."[54]

The upshot of the sittings with Mrs. Robertson was that Sargent became eager to paint her son. His interest was consistent with the impulse that produced many of his best earlier portraits—which had been of individuals with creative dispositions that could engage his own. Robertson did not expect a monument to his ego or a flattering observation of his face. (When Sargent asked him why he had not painted a self-portrait, Robertson replied, "Because I am not my style."[55]) There was no demand for Sargent to cover acres of canvas with jewels, satins, or frills; he could restrain his color scheme and concentrate on a strong silhouette, gradations of dark and light, and fluid brushwork. In fact, Robertson was perfectly amiable when he learned that his sheepdog and the unbroken line of his long, extremely well-cut black overcoat were central to the effect Sargent wished to obtain:

Fig. 9. John Singer Sargent, American, 1856–1925. *Marion Greatorex Robertson,* 1894. Oil on canvas; 63 × 41 in. (160 × 104.1 cm). With permission of the Trustees of the Watts Gallery, Compton, Surrey

No one had ever wanted to paint me before. Portions of me had been borrowed from time to time; hands pretty frequently by Albert Moore, . . . quite a good deal by Walter Crane for immortals of uncertain shape and sex, but I myself proper . . . had never been in request. Even now, as far I as could gather, the dog and the overcoat seemed to be regarded as my strong points; nevertheless, I felt very proud. . . .[56]

Graham Robertson was also an apt choice for a portrait because, like Madame Gautreau and Ellen Terry, he was prepared to be aestheticized in the cause of Sargent's composition. An exhausting physical effort was necessary to maintain the contortion required. "Being but an amateur model," he wrote, "I was easily entrapped into a trying pose, turning as if to walk away, with a general twist of the whole body and all the weight on one foot."[57] In the velvet-collared coat and thus positioned, with

Fig. 10. *W. Graham Robertson, with His Sheepdog, Richard,* early 1930s. Photograph. Collection of Mark Samuels Lasner

his right hand on his hip and his left holding a jade-handled walking stick, Robertson literally embodied a triumph of formal strategies. The figure of Robertson also announced that self-dramatization was a way to gain control over one's life and make one's own social code—the portrait was the pictorial analogue of the pale youth promoted by Wilde, Beerbohm, Montesquiou, and Beardsley, and who was unapologetically disdainful of the philistinism of middle-class tastes. In the words of the art historian Albert Boime, "The lurking shadows, the intense gaze . . . , the nervous hand gestures objectively visualized the undercurrent of anxiety that began to appear in London high society in the mid-1880s."[58]

Those fears, at least for Robertson, appeared to be rooted in an antipathy toward industrialism and mass production, whose uniformity was threatening to obliterate not only the pastoral landscape but human individuality. Like Blake and Rossetti, from whom they descended intellectually, artists like Beardsley, Robertson, and Burne-Jones avoided confrontation with the consequences of urban industrialism by constructing their own stylistic and physical refuges. The flight from modern life and the means to express it meant that rebellion against convention was doomed to become reactionary.

As a child Robertson abhorred machinery, and his hostility only deepened. He too began to run away from his age. (It cannot be accidental that the sole theatrical celebrity of the 1890s whom Robertson did not choose to befriend, and mentions cursorily or critically in his letters, is Shaw, the dramatist who put economic issues at the core of his plays.) Robertson maintained a house in town, in which most of his pictures were hung, but in 1888 he bought Sandhills, a cottage in Surrey, from the Irish poet William Allingham. Allingham's nurse, who had taken care of Carlyle during his last illness and served tea to Tennyson, came with the property, and she became Robertson's housekeeper. The place was antiquated when he got it, and he steadfastly avoided modernizing it. A talisman of the preindustrial world, the house lacked electricity, central heating, and hot water. He lived by candlelight, fires, and tin basins filled by the jug. After one of Gielgud's visits Robertson wrote, "Perhaps you realized that you left London in 1942 and arrived some time in the 1890s."[59]

Many of Robertson's friends and gods were dead by 1900—Moore, Burne-Jones, Wilde, Beardsley, William Morris—and Whistler would follow in 1903. Robertson continued to paint, but he was progressively less happy with the turn art was taking—he laughed at Roger Fry for "floundering in the pig tub of post-impressionism" and trusted that the "ugly wave of vulgar eccentricity and insanity" would ebb.[60] The adventure of the 1890s was over, and Robertson quietly withdrew (fig. 10). In turning inward, he reinvented himself as a prolific writer of children's plays and illustrator of children's books. He drew the frontispiece for the original edition of *The Wind in the Willows* (1908), a tale that imitated his own life. Kenneth Grahame, a friend and London neighbor, confected a fantasy based on a nostalgia for an arcadian age of leisure in which a simple, abundant existence was led according to a pastoral clock, which sweetly duplicated the solipsist idyll that was Sandhills.

Financially able to isolate himself from the everyday realities he found intolerable, Robertson applied his energies to the expansion and improvement of his Blake collection. Since the 1880s, Robertson had busied himself with the descendants of Thomas Butts, Blake's chief patron. He paid many visits to Frederic Butts, one of Thomas's grandsons, while otherwise amassing items from the Butts collection that had been dispersed elsewhere. In 1905 Frederic Butts allowed Robertson to buy *Newton* and *The Good and Evil Angels* (fig. 11), another image from Blake's unsurpassed series of monoprints of 1795. Later in 1905 Frederic Butts died, and his widow sold the 39 Blakes she inherited through the Carfax Gallery, whose director was Robert Ross, Wilde's literary executor and unwavering friend. Because of Wilde, Robertson and Ross had been acquainted for decades, and in 1906 Robertson was given first chance to acquire Frederic Butts's Blakes for the price of £9,000.[61] With ten of the twelve known monoprints in his possession, the high point of Robertson's Blake collection was reached, but he was adding to it as late as 1938, when he was able to buy the eleventh print that others overlooked at auction.[62] As an old man, Robertson observed that his 140 Blakes were "felt to represent one of my few excuses for existence."[63]

Robertson's production as a visual artist dwindled after his mother's death and stopped after the commencement of World War I. Tellingly, his last significant painting, *Self-Portrait with Rachel Hill* (fig. 12), a portrait of himself with a neighbor's child, was executed in 1914. Robertson asserted that the world as he understood it ended abruptly in that year, and that he had no wish to enter "an age to which I do not belong."[64] Servants at Sandhills were told never to mention the war to him, and because nothing was spoken aloud, the household went on pretending the twentieth century had not happened. Robertson's friends thought him oblivious to World War II as well, but in 1939 he took steps to safeguard his collection. The art he valued most was presented to the Tate Gallery, including nine of the eleven large color prints by Blake, Rossetti's *Proserpine,* Sargent's portrait of him, and the view of Valparaiso harbor by Whistler. (Robertson

Fig. 11. William Blake, British, 1757–1827. *The Good and Evil Angels,* 1795/ca. 1805. Color print finished in ink and watercolor on paper; 17½ × 23⅜ in. (44.5 × 59.4 cm). Tate, presented by W. Graham Robertson, 1939, N05057. © Tate London, 2002

Fig. 12. W. Graham Robertson, British, 1866–1948. *Self-Portrait with Rachel Hill,* 1914. Oil on canvas; 36 × 32⅞ in. (91.5 × 83.5 cm). Courtesy of the Russell-Cotes Art Gallery and Museum, Bournemouth, Great Britain

sold the portrait of Rosa Corder while Whistler was still alive, and the artist forgave him for it. It is in the Frick Collection in the same gallery with Whistler's later black portrait of Montesquiou, the canvas Sargent was accused of copying when he painted Robertson because both subjects are similarly posed and outfitted.)

The pictures were immediately removed to the Tate's storage area in a remote part of the island. Robertson's decision turned out to be "a wise precaution," remembered his publisher, Hamish Hamilton, "as the house in Kensington which contained them was later blasted."[65] Robertson had a stroke in 1942, and he finished putting his estate in order by giving the best of everything he owned to the public. He donated his portraits of Ellen Terry and the burlesque actress Nellie Farren to the National Portrait Gallery in London and protected most of the land around Sandhills by deeding it to the National Trust after his death in 1948. Ultimately Robertson donated or bequeathed twenty-one Blakes to the Tate, plus *The Toilette* and several watercolors by Burne-Jones, making him a principal benefactor of the gallery. The Fitzwilliam Museum in Cambridge was given six Blakes, plus money to establish a room—today the gallery is named after Robertson—for the study of watercolors, drawings, and prints. Other works were left to the British Museum, the Victoria and Albert Museum, and the National Gallery of Scotland. When it came to preserving the time in which he reveled, the slender spar of the nineties was more like a boulder of granite.

ACKNOWLEDGMENTS AND NOTES
In investigating a figure like W. Graham Robertson, who sought obscurity and remained successfully locked in its vise, the help of informed colleagues and sympathetic institutions was essential for examining his life and career. Accordingly, it is with pleasure that I express my special gratitude to Mark Samuels Lasner, Washington, D.C., who put his collection and his erudition at my disposal. I am also happy to thank Mark Bills, Russell-Cotes Art Gallery and Museum, Bournemouth; Elizabeth Broman and Steve Van Dyke, Cooper-Hewitt Museum Library, New York City; Susan Grace Galassi, The Frick Collection, New York City; Janeen Haythornthwaite, Whitechapel Art Gallery Archives, London; Heather Perry, Haslemere Educational Museum, Haslemere, Surrey; Romaine Ahlstrom, Susi Krasnoo, and Christine Fagan, The Huntington Library, San Marino, California; and Harold L. Miller, Wisconsin State Historical Society, Madison. Most particularly, I am indebted to David Fraser Jenkins, who recognized the value of an essay on Graham Robertson and his times and encouraged me to write it, and to Chase W. Rynd, who welcomed the inclusion of this study into the Frist Center's exhibition catalogue.

1. James Agate, *Ego: The Autobiography of James Agate* (London: Hamish Hamilton, 1935), 355. Agate (1877–1947) was the drama critic of the *London Times* from 1923 to 1947. John Roddam Spencer Stanhope died in 1908.

2. Agate 1935.

3. Quoted in Richard Ellmann, *Oscar Wilde* (New York: Random House, 1988), 371.

4. Alexander Woollcott to Frances White Emerson, January 4, 1942, in *Letters to Frances White Emerson from W. Graham Robertson* (Cambridge?, Mass.: privately printed, n.d. [1950?]), 53.

5. W. Graham Robertson (WGR) to Marie Ney, February 27, 1936, Box 16, W. Graham Robertson Collection, The Huntington Library, Art Collections, and Botanical Gardens, San Marino, California (WGRC). The book at issue was *England Speaks* (New York: Literary Guild, 1935), by Sir Philip Gibbs.

6. WGR to Marie Ney, April 4, 1934, Box 16, WGRC.

7. WGR, *Time Was: The Reminiscences of W. Graham Robertson (TW)*, (London: Quartet Books, 1981), 38–39.

8. Colleen Denney, "The Grosvenor Gallery as Palace of Art: An Exhibition Model," in *The Grosvenor Gallery: A Palace of Art in Victorian England*, ed. Susan P. Casteras and Colleen Denney, exh. cat. (New Haven, Conn.: Yale Center for British Art, 1996), 9.

9. Susan P. Casteras, "Burne-Jones and the Pre-Raphaelite Circle at the Palace of the Aesthetes," in Casteras and Denney 1996, 76–77.

10. James Abbott McNeill Whistler, *The Gentle Art of Making Enemies* (New York: Dover, 1967), 1.

11. Andrew McLaren Young, Margaret MacDonald, Robin Spencer, and Hamish Miles, *The Paintings of James McNeill Whistler*, 2 vols. (New Haven, Conn.: Yale University Press, 1980), 2:95–97.

12. Quoted in Stanley Weintraub, *Whistler: A Biography* (New York: E. P. Dutton, 1988), 215.

13. The paintings were lent by the Alexander family at the artist's request. McLaren Young et al. 1980, 2:63, 78.

14. *TW*, 49.

15. *TW*, 48–49.

16. Robyn Asleson, *Albert Moore* (London: Phaidon Press, 2000), 41.

17. *TW*, 56.

18. Edith Craig and Christopher St. John, *Ellen Terry's Memoirs* (London: Victor Gollancz, 1933), 95–96.

19. WGR to Kerrison Preston, November 30, 1926, and May 15, 1931, in Kerrison Preston, ed., *Letters from Graham Robertson* (London: Hamish Hamilton, 1953), 172, 251.

20. Avis Berman, "Not Just Another Pale Victorian Aesthete," *New York Times,* September 23, 2001.

21. Quoted in Allen Staley, "'Art Is upon the Town!': The Grosvenor Gallery Winter Exhibitions," in Casteras and Denney 1996, 67.

22. *TW*, 86.

23. WGR to Frances White Emerson, March 2[?], 1943, in *Letters to Frances White Emerson from W. Graham Robertson,* 59.

24. Kerrison Preston, *Blake and Rossetti* (London: Alexander Moring, 1944), 97.

25. Preston 1944, 61.

26. *TW*, 26.

27. Kerrison Preston, introduction to *Letters from Graham Robertson,* ix.

28. *TW*, 33.

29. Robert de Montesquiou to WGR, November 16, 1885, Box 11, WGRC.

30. Montesquiou to WGR, January 9, 1887, Box 11, WGRC.

31. *TW*, 188.

32. Asleson 2000, 188.

33. Staley 1996, 67.

34. Quoted in John Rothenstein, *The Artists of the 1890's* (London: George Routledge & Sons, 1928), 139.

35. Casteras and Denney 1996, 197.

36. Alfred Yockney, "Catalogue of Oil Paintings," in D. S. MacColl, *Life, Work, and Setting of Philip Wilson Steer* (London: Faber and Faber, 1945), 192–93.

37. *TW*, 151.

38. Nina Auerbach, *Ellen Terry: Player in Her Time* (New York: W. W. Norton, 1989), 263.

39. Craig and St. John 1933, 233.

40. The watercolor is contained in a sketchbook of Robertson's from 1888–89 in Box 3, WGRC.

41. Quoted in Staley 1996, 67.

42. *TW*, 49–50.

43. *TW*, 233.

44. Oscar Wilde to WGR, undated [1888?], and May 11, 1889, Box 15, WGRC.

45. Quoted in Ellmann 1988, 305.

46. Ellmann 1988, 365.

47. Prices from McLaren Young et al. 1980, 2:43, 117. As to how little Robertson paid, less than a year later, in April 1891, Whistler sold his portrait of Thomas Carlyle to the Corporation of City of Glasgow, for £1,100. Later that year, the French nation purchased the portrait of his mother for 4,000 francs (£800); the sum was a financial concession that Whistler eagerly made to have his painting in the Musée du Luxembourg and "on its way to the Louvre."

48. For a recent account of Corder's life and work, see Susan Grace Galassi, "Rearranging Rosa Corder," *Apollo* 154, no. 476 (October 2001): 24–36.

49. *TW*, 191.

50. *TW*, 188.

51. *TW*.

52. Virginia Surtees, *The Paintings and Drawings of Dante Gabriel Rossetti (1828–1882): A Catalogue Raisonné,* 2 vols. (London: Clarendon Press, 1971), 1:132–33, 155.

53. *TW*, 233. Robertson quotes his mother about her dislike of being stared at.

54. Marion Greatorex Robertson to WGR, May 20, 1907, Box 12, WGRC.

55. *TW*, 243–44.

56. *TW*, 235.

57. *TW*, 236.

58. Albert Boime, "Sargent in Paris and London: A Portrait of the Artist as Dorian Gray," in *John Singer Sargent,* ed. Patricia Hills, exh. cat. (New York: Whitney Museum of American Art, 1986), 103.

59. John Gielgud, foreword to *TW,* xiii.

60. WGR to Kerrison Preston, February 12, 1914, in *Letters from Graham Robertson,* 17.

61. Kerrison Preston, ed., *The Blake Collection of W. Graham Robertson* (London: Faber and Faber, 1952), 10.

62. WGR to Frances White Emerson, December 16, 1938, in *Letters to Frances White Emerson from W. Graham Robertson,* 33. The missing monoprint that Robertson acquired was *Christ Appearing to the Apostles after the Resurrection.* In this impression, he wrote, viewers were spared "Blake's usual conventionally handsome & curiously unconvincing Christ, but worn and weary; still half dazed with the pains of earth-life and with the sleep in the tomb, but with that strange inward glow & glory that Rembrandt gets in his homely figures of the Redeemer."

63. *TW*, 284.

64. *TW*, 324.

65. Hamish Hamilton, "W. Graham Robertson," unpublished, unpaged manuscript [1948], Box 16, WGRC.

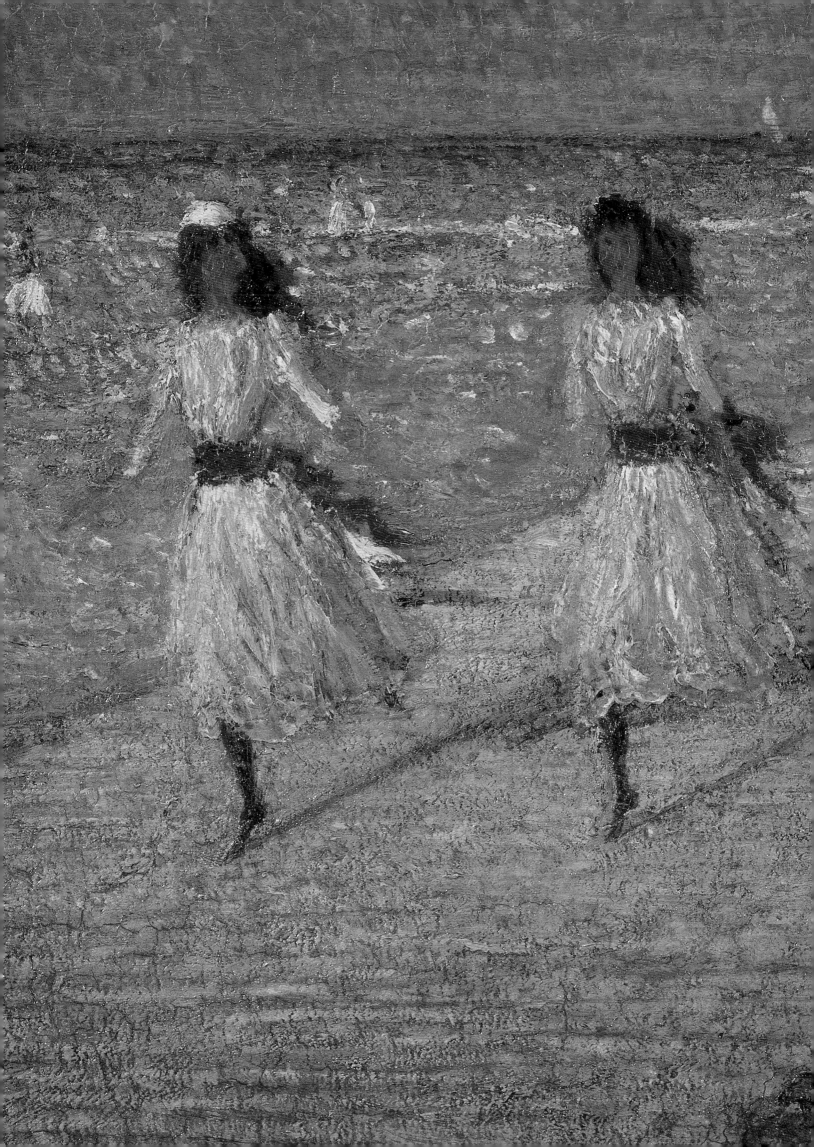

Catalogue

The entries on Whistler have been adapted from texts
by Frances Fowle.

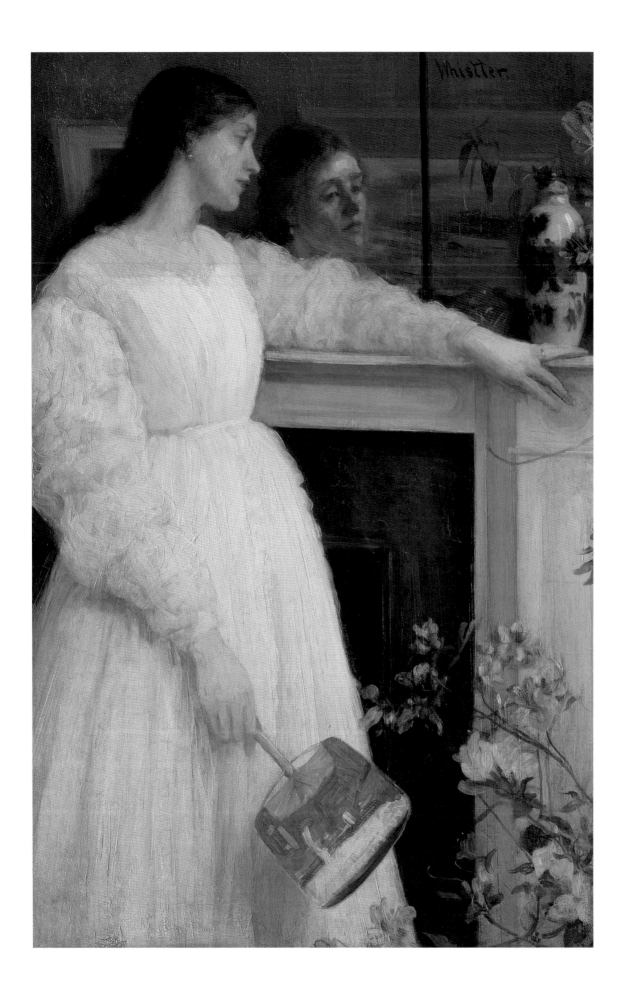

JAMES McNEILL WHISTLER
(1834–1903)

1 *Symphony in White, No. 2: The Little White Girl,* 1864

Oil on canvas
30⅛ × 20⅛ in. (76.5 × 51.1 cm)
Signed upper right: *Whistler.*
Bequeathed by Arthur Studd 1919

This picture was exhibited at the Royal Academy of Arts in 1865 as simply *The Little White Girl.* The model for the picture was Whistler's mistress, Jo Hiffernan, and the location, the house that they shared in Lindsey Row, Chelsea. She is holding a Japanese fan of the type made for the European market. Whistler was fascinated by Japanese art and culture and from an early date collected Japanese objects. The fan, the red pot, the blue-and-white vase on the mantelpiece, and the spray of pink azalea not only give the picture a Japanese feel, but they provide brilliant color notes against the neutral background of black, white, and cream. Pictures hanging in the room are reflected in the mirror, their frames creating a series of right angles which are echoed by the fireplace and the mirror itself, dividing and compartmentalizing the picture like a Japanese print.

The poet Algernon Swinburne was so inspired by Whistler's picture that he composed a verse ballad, *Before the Mirror,* in response. It was intended to complement, rather than explain the picture:

Glad, but not flushed with gladness,
Since joys go by;
Sad, but not bent with sadness,
Since sorrows die;
Deep in the gleaming glass
She sees all past things pass,
And all sweet life that was lie down and lie.[1]

Whistler was delighted with the poem and had it printed on gold paper and pasted onto the frame. In this way he hoped to reinforce the picture's theme of reverie and regret. Recent critics have commented that the reflection seems to show the model looking older than she does in the foreground, as if she sees herself at some future time. She shows off her wedding ring on her hand on the mantelpiece, and Swinburne's poem suggests instead that she is looking at the past. The painting has a concealed narrative, with implications beyond being a glimpse of a charming domestic interior.

In 1887 Whistler exhibited *Symphony in White, No. 3* (Barber Institute of Fine Arts, University of Birmingham). *The Little White Girl* was accordingly given the additional title of *Symphony in White, No. 2,* to underline the importance of reading the picture as an arrangement of colors, and interpreting the mood rather than the subject of the painting. Correspondingly, the first picture in the series, *The White Girl* (Jenkins, fig. 4) became known as *Symphony in White, No. 1.*

1. Algernon Swinburne, *Poems and Ballads* (London, 1866), quoted in Richard Dorment and Margaret F. MacDonald, *James McNeill Whistler,* exh. cat. (London: Tate Gallery Publications, 1994), 79.

2 *Crepuscule in Flesh Colour and Green: Valparaiso,* 1866

Oil on canvas
23⅛ × 29⅞ in. (58.6 × 75.9 cm)
Signed, dated, and inscribed lower left:
Whistler Valparaiso 66
Presented by W. Graham Robertson 1940

The title of this picture indicates that Whistler's main purpose was to capture the effect of twilight through harmonies of color. However, the subtitle, *Valparaiso,* also gives a clue to the subject: the Spanish bombardment of Chile's principal harbor in March 1866.

Responding to the Spanish occupation of the Peruvian-owned Chincha Islands in 1864, the South American countries of Chile, Bolivia, and Ecuador formed an alliance with Peru against Spain. In February 1866 Whistler left London for South America, to assist the Chilean cause. When he arrived in Chile on March 12, a squadron of six Spanish ships was blockading the country's main harbor, Valparaiso. To protect their own nationals and act as a neutral, peacekeeping force, the British, American, and French governments had sent their fleets, which were also present. On March 27, the Spanish announced their intention to bombard the city. Although outraged by this act of aggression, the British, American and French fleets had no option but to withdraw. Whistler's picture almost certainly records the beginning of their withdrawal, on the evening of March 30. The following day the Spanish bombarded the city, by which time Whistler had fled to the hills on horseback.

Whistler painted three other canvases in Valparaiso, all depicting the prelude or aftermath to the hostilities. According to Arthur J. Eddy, he completed this picture "at a single sitting, having prepared his colours in advance."[1] From this we can gather that he was working from memory and that the overall effect was more important than accuracy of detail. The only clearly visible flag is the French tricolor in the center of the composition, silhouetted against the gathering violet and purple clouds.

1. Arthur J. Eddy, *Recollections and Impressions of James A. McNeill Whistler* (Philadelphia and London: J. B. Lippincott, 1903), 23.

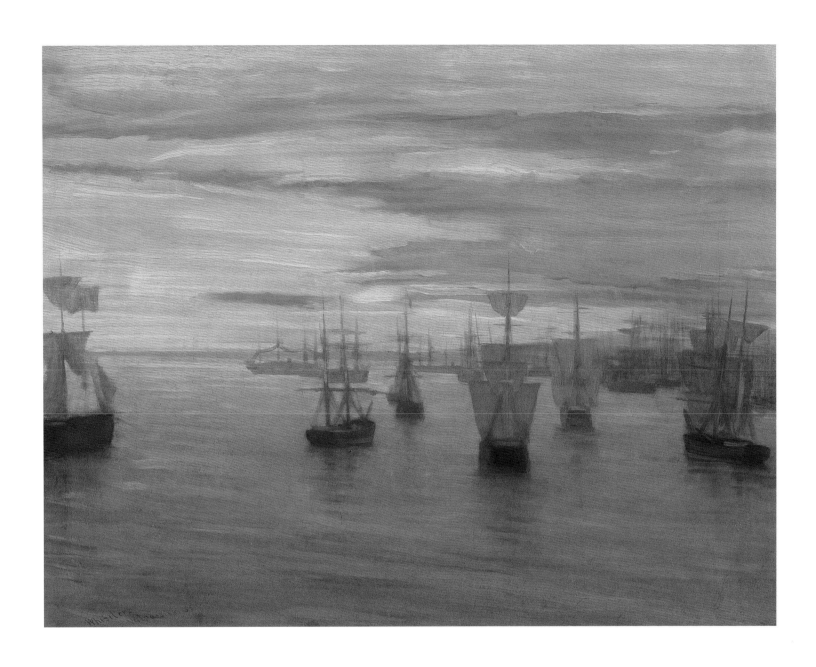

3 *Nocturne: Blue and Silver—Chelsea,* 1871

Oil on panel
19¾ × 24 in. (50.2 × 60.8 cm)
Signed lower center with monogram; dated lower
center: *71*
Bequeathed by Miss Rachel and Miss Jean Alexander
1972

Painted in August 1871, this is the first of Whistler's *Nocturnes.* In these works, Whistler aimed at conveying a sense of the beauty and tranquility of the river Thames by night. It was Whistler's patron Frederick Leyland who first used the name *Nocturne* to describe Whistler's moonlit scenes. It aptly suggests the idea of a night scene, with the musical associations of Frederic Chopin's *Nocturnes* for the piano. The expression was quickly adopted by Whistler, who later explained,

By using the word "nocturne" I wished to indicate an artistic interest alone, divesting the picture of any outside anecdotal interest which might have been otherwise attached to it. A nocturne is an arrangement of line, form and colour first.[1]

Returning from a trip by steamer to Westminster, Whistler was inspired, one evening in August 1871, by a view of the river "in a glow of rare transparency an hour before sunset."[2] He immediately rushed to his studio and painted two pictures, a sunset and this moonlit scene, at one sitting. The picture is painted on panel, primed with dark gray paint, over which Whistler applied thin layers of pigment to create a contrasting sense of luminosity. The view is from Battersea looking across to Chelsea, and it is possible to make out features on the horizon, such as the tower of Chelsea Old Church on the right. In the foreground, a low barge and the figure of a fisherman are indicated with a minimum of detail, and the influence of Japanese art is evident in the restricted palette, the economy of line, and the characteristic butterfly signature.

This picture was exhibited, along with its pair, at the Dudley Gallery in November 1871. The critic for the *Times* revealed a rare appreciation of Whistler's *Nocturnes,* describing them on November 14 as follows:

They are illustrations of the theory . . . that painting is so closely akin to music that the colours of the one may and should be used, like the ordered sounds of the other; that painting should not aim at expressing dramatic emotions, depicting incidents of history or recording facts of nature, but should be content with moulding our moods and stirring our imaginations, by subtle combinations of colour, through which all that painting has to say to us can be said, and beyond which painting has no valuable or true speech whatever.

1. Dorment and MacDonald 1994, 122.
2. Anna Whistler, the artist's mother, in a letter to Julia and Kate Palmer, November 3, 1871, quoted in Dorment and MacDonald 1994, 122.

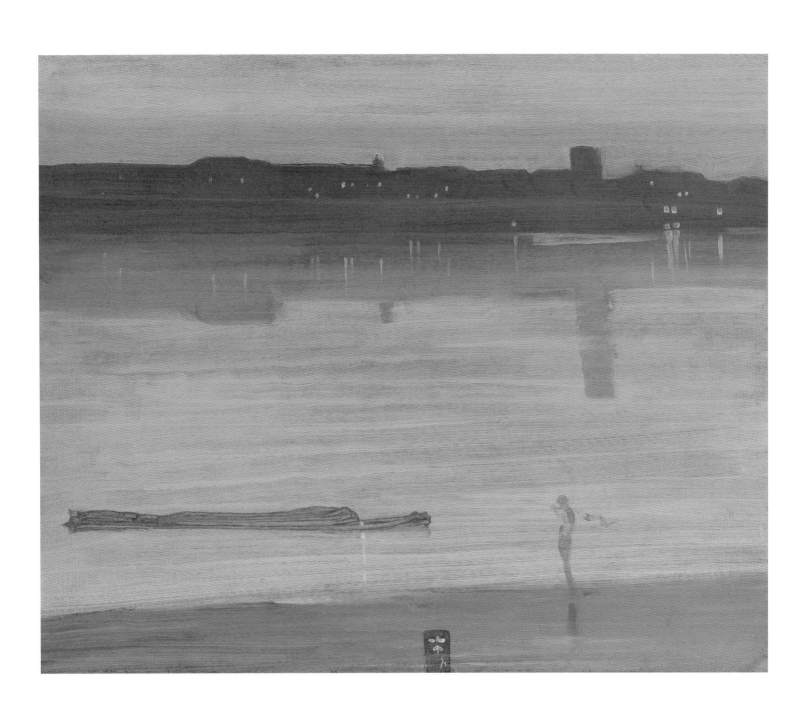

4　*Miss Cicely Alexander: Harmony in Grey and Green,* 1872

Oil on canvas
74⅞ × 38½ in. (190.2 × 97.8 cm)
Signed center left with butterfly
Bequeathed by W. C. Alexander 1932

Cicely Alexander was the daughter of W. C. Alexander, a successful London banker, and was eight years old when Whistler painted this portrait. Alexander may have been introduced to Whistler through their mutual interest in oriental art—Alexander had a collection of Japanese lacquer work and blue-and-white china—and Whistler adds a touch of Japonisme to the portrait through the gold-edged black dado and wall divider and the delicate daisies and butterflies. Whistler also painted Cicely's older sister, Agnes Mary (Tate), and had planned to paint her first but was suddenly inspired to paint the younger girl in the dress and pose of Manet's *Lola de Valence* (1862; Musée d'Orsay, Paris). He gave strict instructions as to how Cicely should be clothed, designing the dress in detail and even giving directions as to where suitable fine Indian muslin material could be found. Even the black-and-white carpet on which she stands was made to order, by the sisters of the artist Walter Greaves. The finished work not only pays tribute to Manet but, through its loose brushwork and tonal handling of paint, also draws on the work of Velázquez, who had portrayed members of the Spanish court in a similar way.

Having controlled so precisely the coloring of his subject, Whistler was determined to match it with his paints and demanded over seventy sittings from the little girl, each lasting several hours. She later recalled the torture to which she was subjected:

I'm afraid I rather considered that I was a victim all through the sittings, or rather standings, for he never let me change my position, and I believe I sometimes used to stand for hours at a time. I know I used to get very tired and cross, and often finished the day in tears.[1]

One of the most compelling aspects of the picture is the austere design, which joins with the precious coloring to create an exquisitely delicate sense of fragile beauty. However, when the picture was first exhibited at the Pall Mall Gallery in 1874, the critics called it "a disagreeable presentment of a disagreeable young lady" and "an arrangement of Silver and bile."[2]

1. Quoted in Elizabeth Robins Pennell and Joseph Pennell, *The Life of James McNeill Whistler,* 2 vols. (London and Philadelphia, 1908), 1:173–74, in Dorment and MacDonald 1994, 146–47.

2. Quoted in Dorment and MacDonald 1994, 147.

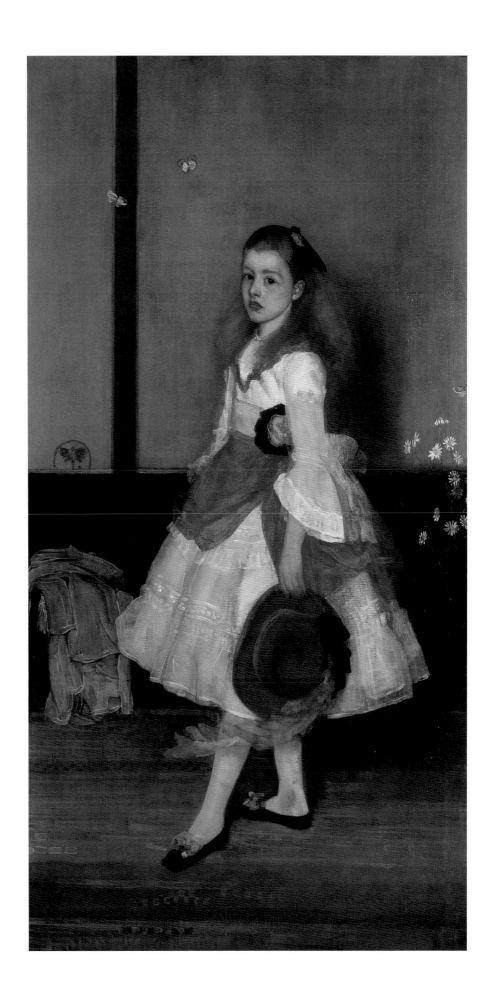

5 *Three Figures: Pink and Grey,* 1868–78

Oil on canvas
54¾ × 73 in. (139.1 × 185.4 cm)
Purchased with the aid of contributions from the
International Society of Sculptors, Painters and
Gravers as a Memorial to Whistler, and from
Francis Howard 1950

This picture derives from one of six oil sketches that Whistler produced in 1868 as part of a plan for a frieze, commissioned by the businessman Frederick Leyland, founder of the Leyland shipping line. Known as the *Six Projects,* the sketches (now in the Freer Gallery of Art, Washington, D.C.) were all scenes with women and flowers, and all six were strongly influenced by Whistler's admiration for Japanese art. The series of large pictures was destined for Leyland's house at Prince's Gate but never produced, and only one—*The White Symphony: Three Girls* (1867)—was finished, but it was later lost. Whistler embarked on a new version, *Three Figures: Pink and Grey,* but was never satisfied with this later painting and described it as "a picture in no way representative, and in its actual condition absolutely worthless."[1] He followed the original sketch closely but made a number of changes, which suggest that the picture is not simply a copy of the lost work. In spite of Whistler's dissatisfaction, it has some brilliant touches and a startlingly original composition.

Although the three figures are clearly engaged in tending a flowering cherry tree, Whistler's aim in this picture is to create a mood or atmosphere, rather than to suggest any kind of theme. Parallels have been drawn with the paintings of his friend Albert Moore, whose work of this period is equally devoid of narrative meaning. The design is economical and the picture space is partitioned like a Japanese interior. Whistler has suppressed some of the details in the oil sketch, effectively disrobing the young girls by depicting them in diaphanous robes. The painting is characterized by pastel shades, a "harmony" of pink and gray, punctuated by the brighter reds of the flowerpot and the girls' bandanas, and the turquoise wall behind.

1. Quoted in Andrew Wilton and Robert Upstone, *The Age of Rossetti, Burne-Jones, and Watts: Symbolism in Britain, 1860–1910,* exh. cat. (London: Tate Gallery Publishing, 1997), 117.

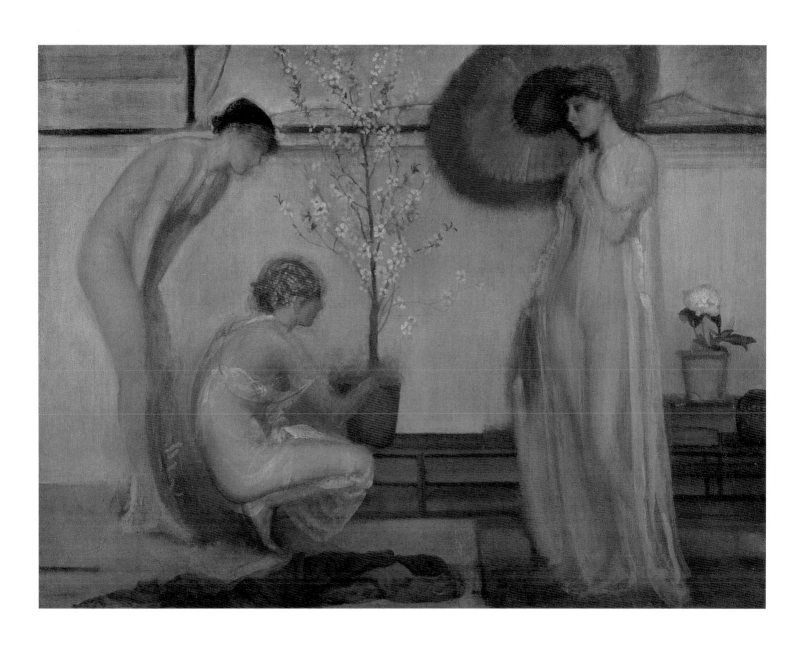

6 *Nocturne: Blue and Gold—Old Battersea Bridge,*
ca. 1872–75

Oil on canvas
26⅞ × 20⅛ in. (68.3 × 51.2 cm)
Presented by the National Art Collections Fund
1905

This is one of Whistler's most controversial works and was produced as "evidence" in the famous *Whistler v. Ruskin* trial of 1878. It is the fifth in the series of *Nocturnes* produced during the 1870s. The central motif is Battersea Bridge, with Chelsea Old Church and the lights of the newly built Albert Bridge visible in the distance. There are fireworks in the sky, and one rocket ascends as another falls in sparks. Almost certainly inspired by Andō Hiroshige's woodcut *Moonlight at Ryogoko* of 1857, which includes a similar tall structure, Whistler intentionally exaggerated the height of the bridge. As the artist himself stated at the Ruskin trial, "I did not intend to paint a portrait of the bridge, but only a painting of a moonlight scene. . . . My whole scheme was only to bring about a certain harmony of colour."[1]

Whistler preferred the calm of the river at night to the noise and bustle of the Thames by day. With the Greaves brothers as his oarsmen, he would set off at twilight and sometimes remain on the river all night, sketching and memorizing the scene. He never painted his *Nocturnes* on the spot but rather from memory in his studio, employing a special medium devised for painting swiftly in oils. He thinned his paint with copal, turpentine, and linseed oil, creating what he called a "sauce," which he applied in thin, transparent layers, wiping it away until he was satisfied.

In 1876 Whistler exhibited the picture as *Nocturne in Blue and Silver, No. 5* but by 1892 had given it its present title. When it appeared at the first Grosvenor Gallery exhibition in 1877, Oscar Wilde wrote that it was "worth looking at for about as long as one looks at a real rocket, that is, for somewhat less than a quarter of a minute."[2]

1. Quoted in Dorment and MacDonald, 1994, 131.
2. Quoted in Dorment and MacDonald, 1994, 130.

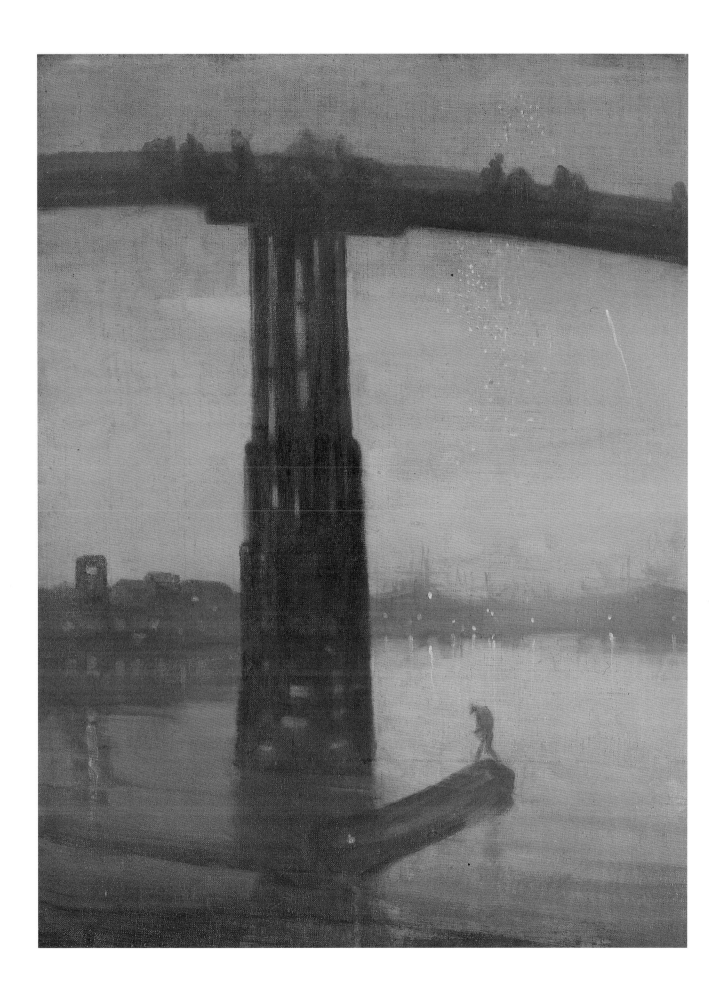

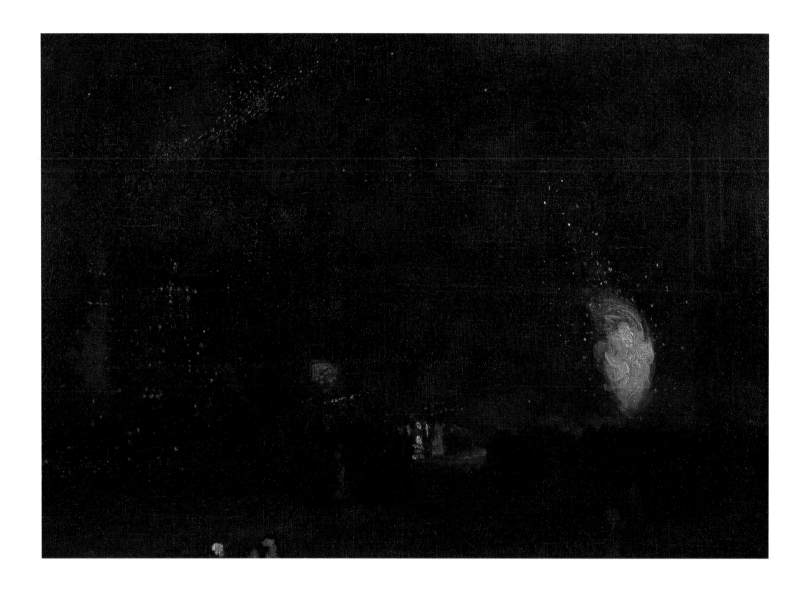

7 *Nocturne: Black and Gold—The Fire Wheel,* 1875

Oil on canvas
$21\frac{3}{8} \times 30$ in. $(54.3 \times 76.2$ cm$)$
Bequeathed by Arthur Studd 1919

This is one of six *Nocturnes* that Whistler painted of Cremorne Gardens in London. The gardens were situated at the west end of Chelsea beside the river, only a few hundred yards from Whistler's own house in Lindsey Row. They could be reached by foot or by steamboat and offered a variety of entertainments, including restaurants, theaters, a "Stereorama," a gypsy grotto, a maze, and an indoor bowling alley, although they had a bad reputation after dark. In all his depictions of the gardens, Whistler ignored the dancing and music which were major features of the nightlife there and focused on the more mysterious and ephemeral activities, such as the nightly display of fireworks. Both this work and *The Falling Rocket* (Berman, fig. 2) show the climax of one of the pyrotechnic displays, which were held every evening on the Cremorne fireworks platform, known as the Grotto. A crowd of spectators, their backs turned to us, are watching the spectacular Catherine wheel as it revolves in the night sky, throwing off a shower of sparks. A tiered fountain strung with fairy lights is just visible to the left of the picture, with trees to left and right.

The picture has darkened, and the companion *The Falling Rocket* is also dark. It was the latter picture that was the subject of Ruskin's disparagement, against which Whistler sued for libel.

8 *Study of Mme Gautreau,* ca. 1884

Oil on canvas
81¼ × 42½ in. (206.4 × 107.9 cm)
Presented by Lord Duveen through the National
Art Collections Fund 1925

The status of this painting is mysterious. It is an unfinished version of the famous portrait of "Madame X" that Sargent exhibited at the Paris Salon in 1884, and it belonged to Sargent all his life, being taken out of his studio sale in 1925 to be given to the Tate Gallery. The finished portrait, which belongs to the Metropolitan Museum of Art, New York (Jenkins, fig. 12), was redrawn several times on the canvas, so that there are visible many slight alterations to the profile of the head. The Tate's painting is precisely the same in its profile and therefore must have been traced from the completed original, rather than being a preliminary study for it. It is unknown whether Sargent began this as a copy or whether at one stage he considered that the first painting was overworked and that he should begin again on a new canvas; both canvases are the same size. It was abandoned at an early stage, and someone, perhaps Sargent, painted the comic face in the blank part of the canvas at the left, which has no connection with the portrait.

"Madame X" was an American from New Orleans, born Virginie Avegno, and had been brought up in Paris, where she married the banker Pierre Gautreau. She was known as a society beauty, and Sargent asked, through a common friend, if he could paint her portrait, remarking that he was attracted to her

"beautiful lines" and to the extraordinary coloring of her made-up skin. The portrait took sixteen months to complete, and there are a number of drawings and oil sketches for it, as Sargent tried out different poses. It was an original design, and daring in the discomfort of the pose, the sharp and idiosyncratic profile, and the peculiar pallor of her flesh. At its display in Paris the portrait was considered an offense, in part because the right shoulder strap of her already low-cut dress was depicted fallen off her shoulder. Sargent repainted the shoulder strap, but he retained the portrait and did not exhibit it again until 1905 in London. He eventually sold it to the Metropolitan Museum in 1915. With this picture Sargent surpassed his teacher in Paris, the French portrait painter Carolus Duran, who also devised challenging portraits of society figures for the annual Salon exhibitions.

Although Sargent sent portraits to the Paris Salons of 1885 and 1886, they were of British and American sitters, and he did not subsequently find patronage with the French. In fact his sitters had often been American, but the lack of success of *Madame X* may have contributed to his move to London in the mid-1880s. It was in London that he turned to an interest in Impressionist landscape painting and rebuilt his portrait practice largely through periods of work in New York and Boston.

9 *Claude Monet Painting by the Edge of a Wood,* ca. 1885

Oil on canvas
21¼ × 25½ in. (54 × 64.8 cm)
Presented by Miss Emily Sargent and Mrs. Ormond
through the National Art Collections Fund 1925

Sargent was a great admirer of the landscapes of Claude Monet and bought several paintings from him in the late 1880s. They became friends and exchanged visits, despite the extreme difference between Sargent's portraits and Monet's landscapes, and despite Sargent's relation with his smart patrons in society, which Monet might have thought compromising. Sargent had earlier painted out-of-doors in France and especially in Venice, but at this time had evidently decided to reeducate himself and deliberately studied the Impressionist painting technique of the 1880s. This informal sketch, which Sargent retained during his life, is both a depiction of the activity of out-of-doors painting and an example of such painting. Monet is shown manipulating

the most formidable spread of shrill colors from his palette to his canvas, his painting arm out of focus as he dabs away, relying for his painting entirely on observation with no drawings or sketches beside him. The sketch has been dated to about 1885 through the identification of the picture Monet is working on with a view of haystacks at Giverny, of thirty by forty inches, which he began in June of that year (fig. 1).

The situation with direct landscape painting was more complicated than is suggested by this oil sketch. Monet certainly painted large canvases out-of-doors but often only completed them after several years' work, much of it in the studio. Sargent's sketch, although showing that he was there with Monet, also shows the differences between his attitude and Monet's. It is in part a narrative and not a pure landscape, since it tells the story of Monet at work and his easy relationship with a companion, probably his stepdaughter. It is also not strictly Impressionist in style and is rather an oil sketch with naturalistic coloring, and does not have the tightly structured arrangement of color and design that is typical of Monet's painting at that date.

Sargent often painted his artist friends in the act of painting. He made a brilliant sketch of the French painter and etcher Paul Helleu in 1889, again showing him in an almost voyeuristic fashion actually applying paint with a brush and slightly imitating Helleu's own way of painting figures with exaggerated, spiky limbs (Brooklyn Museum of Art). Later in his career, when he worked out-of-doors with watercolor, Sargent regularly showed his friends at work in the gardens and landscape of Italy, as with his watercolor of 1908 in this exhibition.

Fig. 1. Claude Monet, French, 1840–1926. *Meadow with Haystacks near Giverny,* 1885. Oil on canvas; 29⅛ × 36¾ in. (74 × 93.5 cm). Museum of Fine Arts, Boston: Bequest of Arthur Tracy Cabot, 42.541

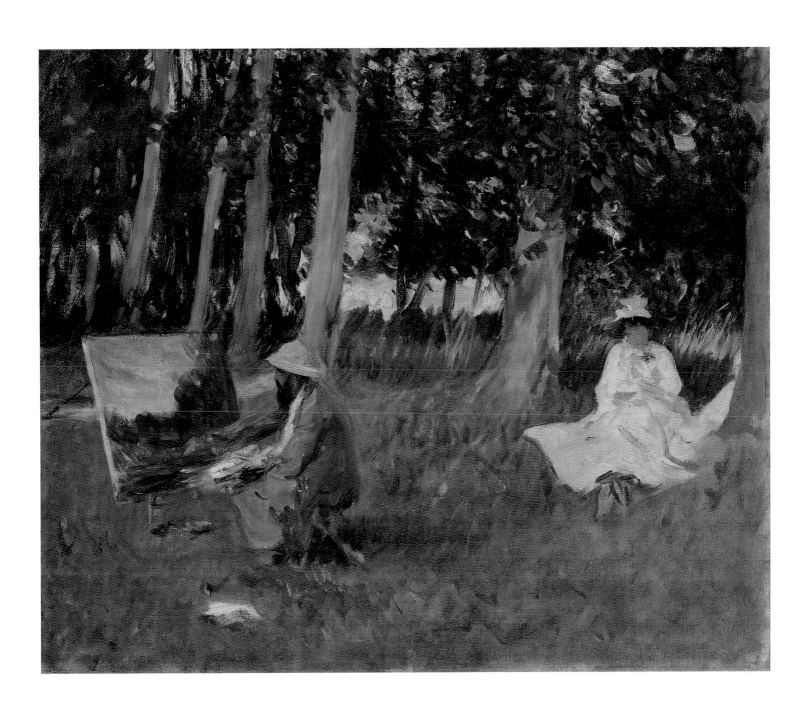

10 *Mrs. Frederick Barnard,* 1885

Oil on canvas
41 × 22½ in. (104.1 × 57.1 cm)
Signed upper right: *John S Sargent*
Bequeathed by Miss Dorothy Barnard 1949

Mrs. Barnard was the wife of the well-known illustrator Frederick Barnard, and the couple became close friends of Sargent. He painted this informal portrait of her late in 1885, while he was staying in the village of Broadway in the Cotswold hills in Worcestershire. The area was an artists' colony, particularly for Americans, and a center of escape from London during the summer for writers as well as painters. Sargent was then in the process, interrupted until the following summer, of painting the Barnards' two daughters in an out-of-doors naturalistic portrait that he called *Carnation, Lily, Lily, Rose* (borrowing the refrain of a song in reference to the flowers in the painting; Tate Britain).

The portrait of the two girls was especially remarkable for its lighting, contrasting the warm light of sunset with the light from Japanese lanterns, and this picture of their mother is also a study of lighting. She appears to be standing near a fire, so that the light is warmly colored and catches the huge sleeves of her vastly cushioned dress from below. The dress is depicted freely, in contrasted tones of light and shade, but her features are modeled traditionally, with a delicate drawing of the mouth and upturned nose.

Sargent was invited in 1886 to be a founding member of the artists' exhibiting society in London that was to be called the New English Art Club, set up as a rival to the Royal Academy. He and Philip Wilson Steer were the most advanced artists among the group, in the sense of developing an Impressionist way of working. This portrait was sent to the first exhibition of the club in April that year, where it seemed modern both for the white monochrome and the direct painting.

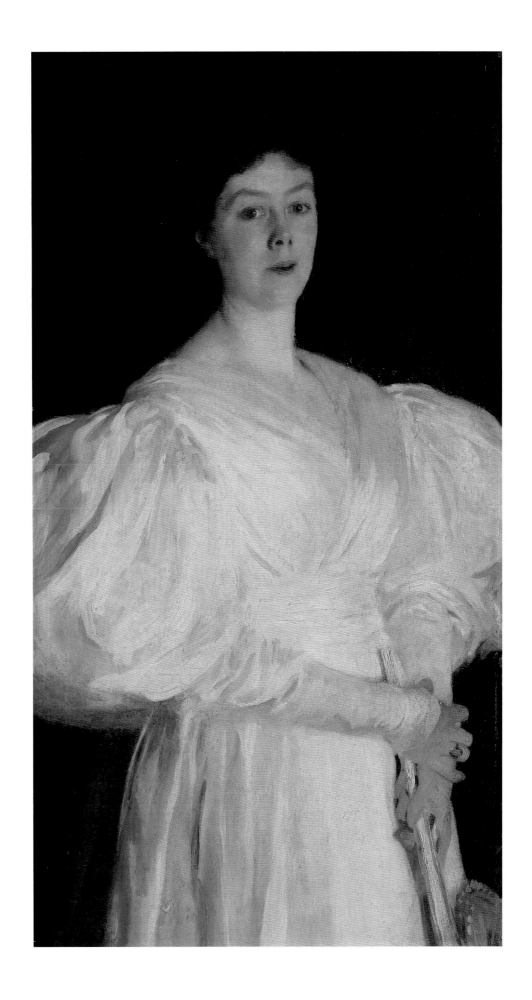

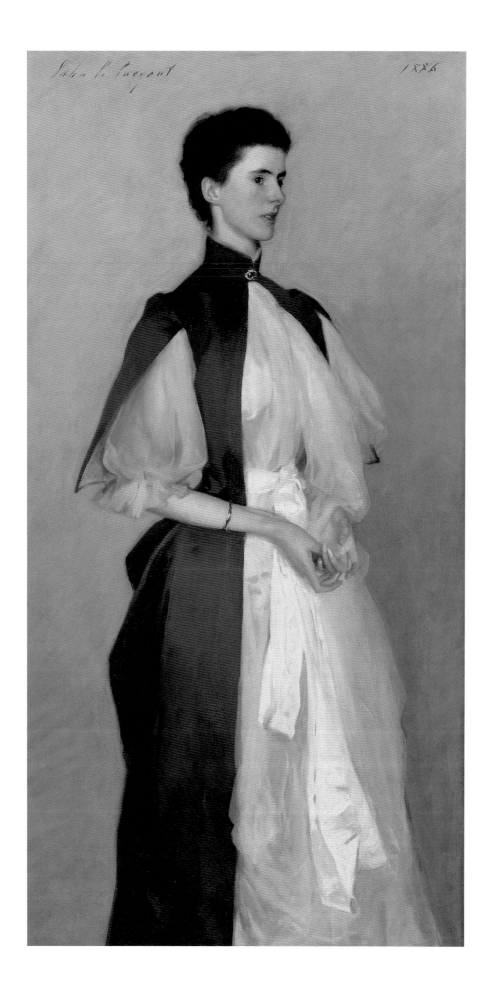

11 *Mrs. Robert Harrison,* 1886

Oil on canvas, 62⅛ × 31⅝ in. (157.8 × 80.3 cm)
Signed upper left: *John S. Sargent;* dated upper right:
1886
Bequeathed by Miss P. J. M. Harrison 2000

The portrait of Mrs. Harrison is outstanding for the clarity of its coloring, which is based on a simple scheme of reds with black and white. The pose is a straightforward three-quarter view, with no background or properties. It might have been understood on its exhibition at the Royal Academy in London in 1886 as a re-creation of a classic old master English portrait, except that Sargent uses his skills in design and in creating an illusion to introduce tensions throughout the picture. The vertical line of Mrs. Harrison's sumptuous red cloak, which undulates slightly along her body, places her head, with its blushes of strong pink, at the summit of a stark, abstract pattern like a flower on a stem, surrounded by cutting, pointed shapes. The colors reverberate through the silk and lace dress, where her arm shows pink through the material, and the further side of the lined cloak appears around the edge of the dress at the right. Most remarkable, her long fingers interlock as if in stalled movement, with the pressure of tension showing in their spots of coloring, and the irregular unclenching of her left hand echoes upside down the points of the cloak on her shoulders.

In the years immediately following his move to London, Sargent lacked commissions for portraits and relied on friends like the Harrisons to give him work. He advertised by showing the portrait at the Academy, but it was attacked by critics. Their dislike was perhaps due to the tension visible in the representation. The critic of *The Athenaeum* referred to the portrait's "rawness and crudity of an uncompromising treatment of the features, forms and expression"[1]—as if the picture were taken to be too realistic to be anything other than vulgar.

Robert Harrison was a London stockbroker, whose country house Shiplake Court was (and remains) beside the river Thames at Henley. Sargent stayed with the Harrisons the following summer, 1887, and set up a studio on a punt. He took this on the family's outings on the river and made Impressionist oil sketches of them and their friends in the sunlight.

1. Quoted in Gary A. Reynolds, "Sargent's Late Portraits," in *John Singer Sargent,* ed. Patricia Hills, exh. cat. (New York: Whitney Museum of American Art, 1986), 151.

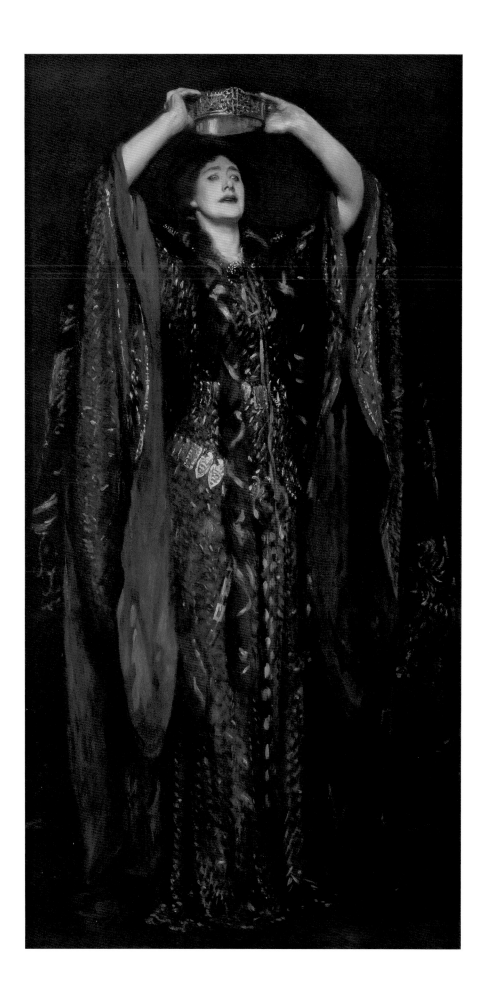

12 *Ellen Terry as Lady Macbeth,* 1889

Oil on canvas
87 × 45 in. (221 × 114.3 cm)
Signed lower left: *John S. Sargent*
Presented by Sir Joseph Duveen 1906

Sargent was devoted to music and the theater, and went, for instance, to Beyreuth in Germany to see a performance of Richard Wagner's *Tristan und Isolde* in 1886. In December 1888 he saw the first performance at the Lyceum Theatre in London of a new production of Shakespeare's *Macbeth,* with Sir Henry Irving and Ellen Terry in the leading roles. Sargent was attracted to extreme performances, whether by Madame X posed in evening dress or by Lady Macbeth as a Celtic sovereign, and he immediately asked Terry to pose for him wearing her striking costume. The design of this had been copied from studies of medieval dress, in the interest of seeking historically accurate settings for plays. The designer recalled:

It was cut from fine Bohemian yarn of soft green silk and blue tinsel after costume designs by Viollet le Duc. Irving did not think it brilliant enough, so it was sewn all over with red green beetle wings and a narrow border of Celtic design worked out in rubies and diamonds. To this was added a cloak of shot velvet in heather tones upon which griffins were embroidered in flame-coloured tinsel. The wimple and veil was held in place by a cordet of rubies and two long plaits twisted with gold hung to her knees.[1]

These deep and pagan colors, with their beetles and griffins, enrich the portrait as a middle tone between the dark background and the radiant colors of Terry's arms and face, as she lifts the crown of Scotland to her head. The figure is more than life size and made the more unusual by the heavy frame decorated with Celtic knots.

The portrait was shown at the New Gallery, a rival to the Royal Academy, in 1889 and was bought by Irving for display at his theater. In 1893 it was lent to the World's Columbian Exposition at Chicago.

1. Mrs. Comyns Carr, *Reminiscences* (1926), 211, quoted in Richard Ormond and Elaine Kilmurray, *John Singer Sargent: Complete Paintings,* vol. 1, *The Early Portraits* (New Haven and London: Yale University Press for The Paul Mellon Centre for Studies in British Art, 1998), 188.

W. Graham Robertson, 1894

Oil on canvas
90¾ × 46¾ in. (230.5 × 118.7 cm)
Signed and dated lower right: *John S. Sargent 1894*
Presented by W. Graham Robertson 1940

W. Graham Robertson is described in the essay by Avis Berman in this catalogue; he was a fellow artist, ten years younger than Sargent. According to Robertson, writing of the occasion years later, a friend passed on a message from Sargent:

"Well, he's very anxious to paint you."
"Me?"
"Yes. He wants you to sit for him."
"Wants me? But good gracious why?"
"I don't know. He says you are so paintable: that the lines of your long overcoat and—and the dog—and—I can't quite remember what he said, but he was tremendously enthusiastic."[1]

This suggests, if reported correctly, that Sargent already had a portrait in mind after meeting Robertson, whom he knew only slightly, and his idea had to do with the clothes Robertson should wear. It was thus the case that another of Sargent's outstanding portraits, like Madame Gautreau and Ellen Terry, was made at the artist's request and for exhibition, though after it was shown in London and Paris it was acquired by Robertson himself. The dark coloring is reminiscent of the work of other London painters of the 1890s, such as William Nicholson and James Pryde, and the attraction of the overcoat was presumably in part its coloring and matte texture, which contrasted with the sitter's rather overrefined hands and pale face. Robertson also recorded that he had to stand for so long, in an awkward pose with his weight on one leg, that on one occasion he went so numb that he could not move, and Sargent had to carry him out into the street to get some air.

1. W. Graham Robertson, *Time Was: The Reminiscences of W. Graham Robertson* (London: Quartet Books, 1981), 235.

14 *Preliminary Relief of Crucifixion,* 1897–99

Bronze relief with polychromed patina
44 × 31 × 3½ in. (111.8 × 78.7 × 8.9 cm)
Presented by A. G. Ross in accordance with
the wishes of the late Robert Ross through
the National Art Collections Fund 1919

The mural decoration of the upper staircase hall at the Boston Public Library, although now difficult to see as the surfaces are dusty and the lighting is poor, was Sargent's most ambitious work. He had once worked while a student on an allegorical ceiling painting in the Musée du Louvre, but this was otherwise a striking departure from his previous work, which had always depicted real events, even if they had sometimes been much rearranged. This sculpture is a one-third-size study for the crucifix at the center of one of the side walls, where it faces the visitor who climbs the stairs. The lower crossbar represents the cornice of the room, which the crucifix cuts across. The crucified Christ is shown as the Redeemer, with figures of Adam and Eve bound to him, catching the blood from his hands in two chalices.

This commission was given to Sargent in 1890. The first section was installed in 1895, and the next, the wall with this sculpture, in 1903. The new library by Charles McKim and Stanford White was built in the grandest Renaissance style of an Italian palace, and the lower staircase was already allocated to the most celebrated muralist in France, Pierre Puvis de Chavannes. Sargent's subject, given to him but with his agreement, was the Triumph of Religion, for which he undertook to review the history of Christianity. The design of this crucifix reflects his research visits to churches in Spain and Sicily. The overall effect of this library wall is of a Byzantine design with references to the jeweled and flashy style of Art Nouveau, and with long inscriptions attached at several points, appropriately for a library. Although the design is strictly hieratic and symmetrical, the lower parts of the mural are based on portrait studies of models, so that there is an intriguing presentation of the individual within the religious structure.

The technical advice for the making of the sculpture was given by Sargent's friend the sculptor Augustus Saint-Gaudens, who was then living in Paris but also working on commissions in Boston.

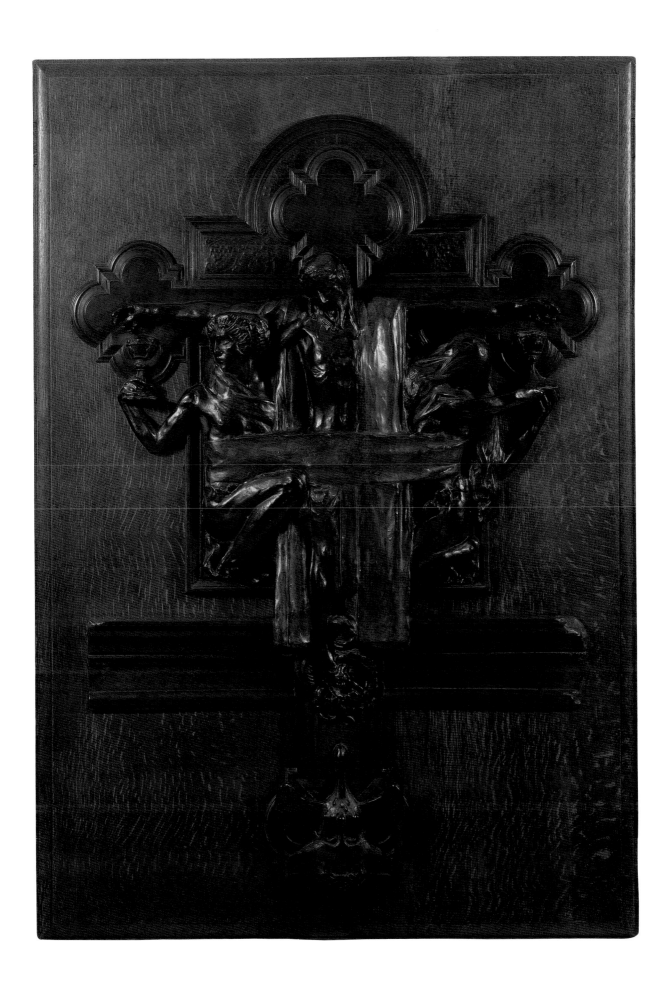

15 *Asher Wertheimer*, 1898

Oil on canvas
58 × 38½ in. (147.3 × 97.8 cm)
Signed upper left: *John S. Sargent*; dated upper
right: *1898*
Presented by the widow and family of Asher
Wertheimer in accordance with his wishes 1922

The portraits that Sargent painted of the Wertheimer family, of which this was the first, are unique in British art of the time: there were so many of them (twelve in all); they were so flamboyant and well known since they were displayed in turn at the Royal Academy; and they have remained together, since all but two of them were eventually given to the National Gallery (and later transferred to the Tate Gallery). The series began with the commission to paint Asher and his wife on their silver wedding anniversary. He was a prominent art dealer in old master paintings and French furniture in London and had a gallery in New Bond Street. Sargent chose to paint

him almost in grisaille, with a range of grays and flesh color, much as he had with Graham Robertson, and also again added a dog, here Wertheimer's black poodle. When the portrait was shown at the Royal Academy, a critic wrote of its "profound and courageous sense of humour," which perhaps referred to the relaxation of the presentation—with Wertheimer evidently proud of his direct and challenging address to the viewer and of the wealth implied by his clothing and the cigar. He turns slightly to the viewer's left, and the companion portrait of his wife (New Orleans Museum of Art) turns slightly to our right, to make a conventional pair of portraits. She is dressed in white and is covered in jewelry, but this portrait was effectively replaced by a new one painted in 1904, which was given with the others to the nation. In this second view, she was then also dressed in black and looks considerably more severe.

The series of Wertheimer portraits were left to the British national collection in 1922 and transferred to the Tate Gallery in 1926, soon after Sargent's death. The portraits were installed, with the gallery's other Sargents, in a large room, which was beside the room showing the Impressionist and Post-Impressionist paintings, and which included Georges Seurat's large *Bathers at Asnières*. Thus for a long period these Edwardian portraits were contrasted to French modernism (fig. 1).

Fig. 1. Tate Gallery, Sargent room, 1926. © Tate London, 2002

16 *Ena and Betty, Daughters of Mr. and Mrs. Asher Wertheimer,* 1901

Oil on canvas
73 × 51½ in. (185.4 × 130.8 cm)
Signed and dated lower right: *John S. Sargent 1901*
Presented by the widow and family of Asher
Wertheimer in accordance with his wishes 1922

A few years after painting the Wertheimer parents, Sargent accepted the first of continuing commissions to paint their four sons and six daughters. In many of the portraits they are grouped as two or three figures together. The motivation for these commissions was in part friendship, as Sargent became a close friend of the family, but the project challenged aristocratic patronage in its scale. The completed portraits were assembled together in a single room at the Wertheimers' house in Mayfair.

This double portrait was shown at the Royal Academy simply titled *Daughters of A. Wertheimer, Esq.,* though it is usually known now by their names, Betty, then aged twenty-four, on the left, and Helena, called Ena, on the right, then aged twenty-seven. They are shown in their parents' house, with the rich furnishing of old master paintings hung close together on the wall behind them, with a French commode and a huge Japanese vase beneath the pictures. Ena holds the knob of the vase in one hand and has her other arm clasped around her younger sister. They are shown in the attitude of pausing on entry into the room, with the details of their hands and facial expressions as if caught at a moment. In particular Betty holds a fan vertically toward the viewer, as Sargent shows off a bravura performance of painting. The coloring is controlled, with the reds of one dress and the flowers and ribbons in their hair emphasizing the differing radiance of their faces.

Sargent had earlier painted the young children of the Boit family (1882; Museum of Fine Arts, Boston) seen in a dim interior light, where they were dwarfed by huge oriental vases. This was one of his first masterpieces, and the setting of these Wertheimer daughters may have been a deliberate riposte to the nervous hesitation of the much younger children, in contrast to the confidence of the young Edwardian adults.

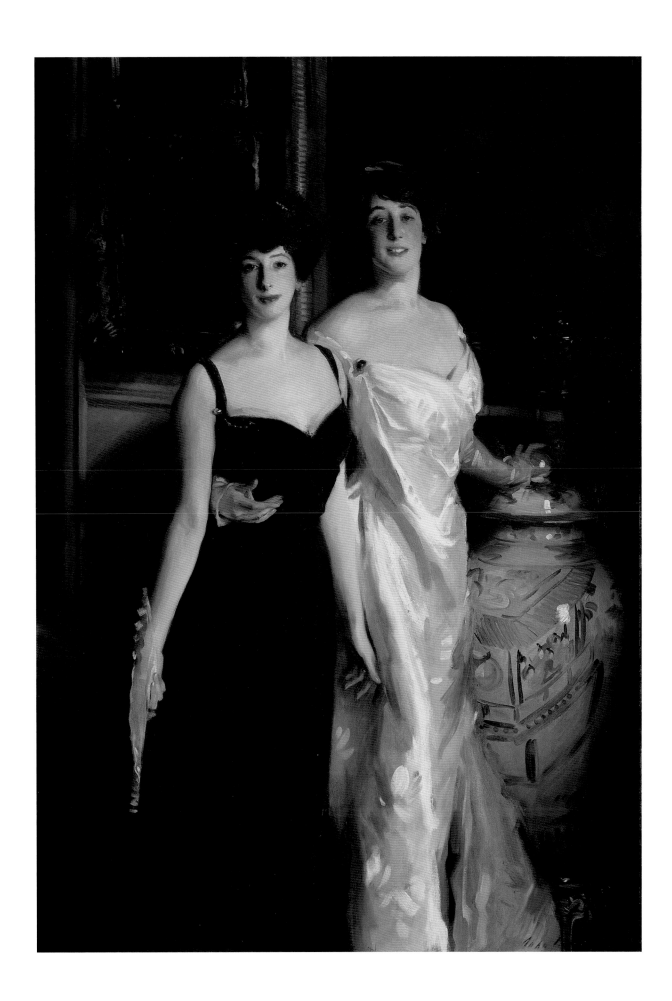

17 *The Misses Hunter,* 1902

Oil on canvas
90¼ × 90½ in. (229.2 × 229.9 cm)
Signed lower right: *John S. Sargent*
Presented by Mrs. Charles Hunter through the
National Art Collections Fund "in memory of
a great artist and a great friend" 1926

There was a fashion in London about 1900
for spectacularly large portraits of sisters,
and Sargent produced for private patrons the
huge *Wyndham Sisters* in 1899 (The Metropoli-
tan Museum of Art, New York) and *The Acheson
Sisters,* 1902 (Chatsworth House). The latter
portrait was exhibited at the Royal Academy
in the same year as *The Misses Hunter.* These por-
traits were intended to revive the tradition of
large portraits of aristocrats which could be
seen in British country houses, and it was the
portrait of the Hunter sisters that gave the
occasion to the French sculptor Auguste Rodin,

who saw it at the Royal Academy on a visit to
London, and who had known Sargent in the
past, to refer to him as "the Van Dyck of our
times." Rodin, a generation older, had made
a comparable move in his own work and was
accepting commissions from rich European
and American collectors for portrait busts.
Mrs. Hunter, the mother of these sitters, was
a friend of both artists (fig. 1). She was a well-
known hostess in Edwardian London, and
the portrait reflects Sargent's position as the
leading society portrait painter and one of
the creators of the image of opulence of this
society.

The three sisters posed for this portrait in
Sargent's studio in Chelsea, where there was a
large room that itself resembled a palace inte-
rior, with decorative columns and Sargent's
own copies of large paintings by Velázquez and
El Greco. Two of the sisters link hands, as they
sit around a circular sofa. The viewing posi-
tion is close and placed so that Sargent, who
was tall, looks down on them, and their dog is
seen almost from above, close to the picture.
This particular portrait is not, despite Rodin's
comment, modeled on Van Dyck, except in its
scale. It is remarkable how Sargent could vary
the kind of composition of his paintings, some-
times using a Baroque linkage of poses, and
sometimes, as here, painting quite directly a
simple scheme of relaxed positions.

Fig. 1. Auguste Rodin, French, 1840–1917.
Mrs. Charles Hunter, 1906. Stone; 34½ × 22¼ ×
18 in. (87.6 × 56.5 × 45.7 cm). Tate, presented
by Mrs. Charles Hunter, 1925, N04116. © Tate
London, 2002

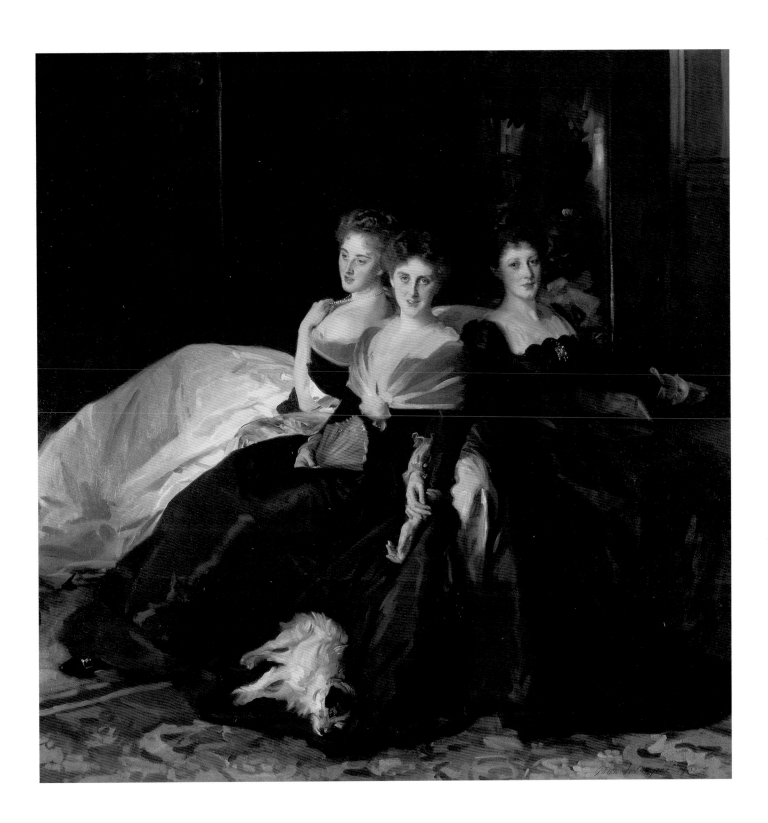

18 *The Mountains of Moab,* 1905

Oil on canvas
25¾ × 43¾ in. (65.4 × 111.1 cm)
Purchased 1957

Sargent planned to spend the winter of 1905–6 escaping from portrait commissions, traveling in Syria and Palestine, where he sought ideas for his presentation of the Triumph of Religion in the Boston Public Library murals, although he had by then completed much of the room. He had already traveled a great deal around the Mediterranean, in Spain, Sicily, Egypt, Greece, and Turkey, in part in connection with this study of religious art. In the Near East he painted a number of landscapes, both in oils and watercolors, but although these may have been some general assistance for him in visualizing the mural paintings, they cannot have been of direct use to his figure compositions there, and it is evident that he became entranced by landscape painting for itself. This was a departure, and, for instance, the large monograph on his work published in 1903 included no landscapes.[1] These paintings are less freshly colored than his previous group of landscape sketches, the Impressionist views of the Cotswolds painted in the 1880s, but they were also painted directly on the spot, on an easel set up in the landscape. The change in coloring, and in the representation of light, is paralleled in the change in coloring of his portraits. Sargent showed this landscape at the Royal Academy in 1906.

The Mountains of Moab are on the east side of the Dead Sea. Sargent frequently chose to paint views of great isolation, and later on he was attracted to the largest and grandest ranges of mountains that he could find, going to the European Alps and the American Rockies. In his letters of this time he wrote of wishing to escape from people, both from their company and from the necessity of close contact with people in the portrait studio. While he was staying near the river Jordan he received a telegram telling him that his mother had unexpectedly died in London. Sargent immediately cut short the visit, returning first to Jerusalem to await transport home.

1. *The Work of John S. Sargent,* with an introductory note by Mrs. Meynell (London: William Heinemann, 1903).

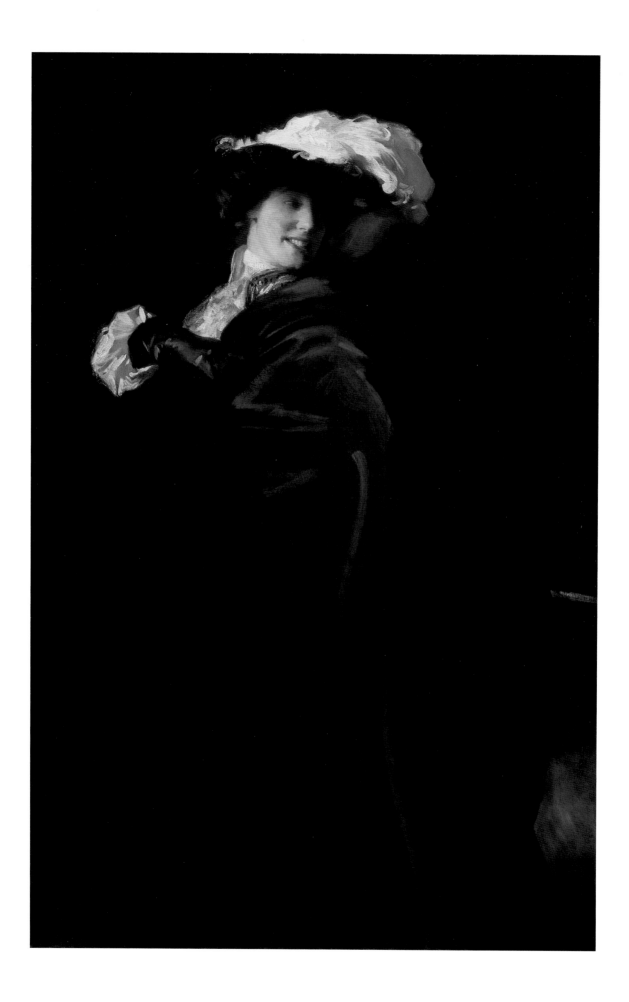

19 *Portrait of Ena Wertheimer: A Vele Gonfie,* 1905

Oil on canvas
64⅛ × 42½ in. (163 × 108 cm)
Bequeathed by Robert Mathias 1996

This is the second of Sargent's portraits of
Helena Wertheimer, who appears with her
sister in the double portrait of 1901. The
Italian of the title means "in full sail" and
refers jokingly to the billowing cloak around
the sitter. She is shown wearing a man's
cloak, apparently borrowing the costume of
a Knight of the Garter that was being worn
by a man also sitting to Sargent in the same
period. This was probably the marquis of
Londonderry, whom Sargent was painting
in his coronation robes.

20 *Almina, Daughter of Mr. and Mrs. Asher Wertheimer,*
1908

Oil on canvas
52¾ × 39¾ in. (134 × 101 cm)
Signed upper left: *John S. Sargent;* dated upper
right: *1908*
Presented by the widow and family of Asher
Wertheimer in accordance with his wishes 1922

Almina Wertheimer, like her sister Helena in the portrait of 1905, is shown by Sargent wearing fancy dress. It was the second time she had been painted, as she had appeared also in 1905 in a group of three with a sister and a brother. This was to be the last of Sargent's paintings of her family. The costume and the musical instrument belonged to Sargent, and the buttoned blouse reappears worn by someone else in another of his pictures. The oriental setting is no more than a pretense, just as the slices of melon and the fruit in a silver bowl in the foreground give a comic hint of something exotic. In this portrayal of a young sitter, whom he had known since she was a child, Sargent allowed the two of them an extra device of framing: not just in looking like an old master portrait (Van Dyck had painted a similar picture of a Lady Shirley in 1622, now in The National Trust, Petworth House, Sussex) but in dressing up like someone pretending to be an old master portrait.

By 1908 the practice of painting in Britain had changed, and there was a younger generation of artists using a variety of styles based on different aspects of modern painting in France, all of them relying on dry surface coloring, whether bright or dull. The bravura application and the modulated colors of the face in this portrait would have seemed out of date, and Sargent, in his early fifties and about to retire from portraiture, gave this costume piece a feeling not only of pretense but of nostalgia.

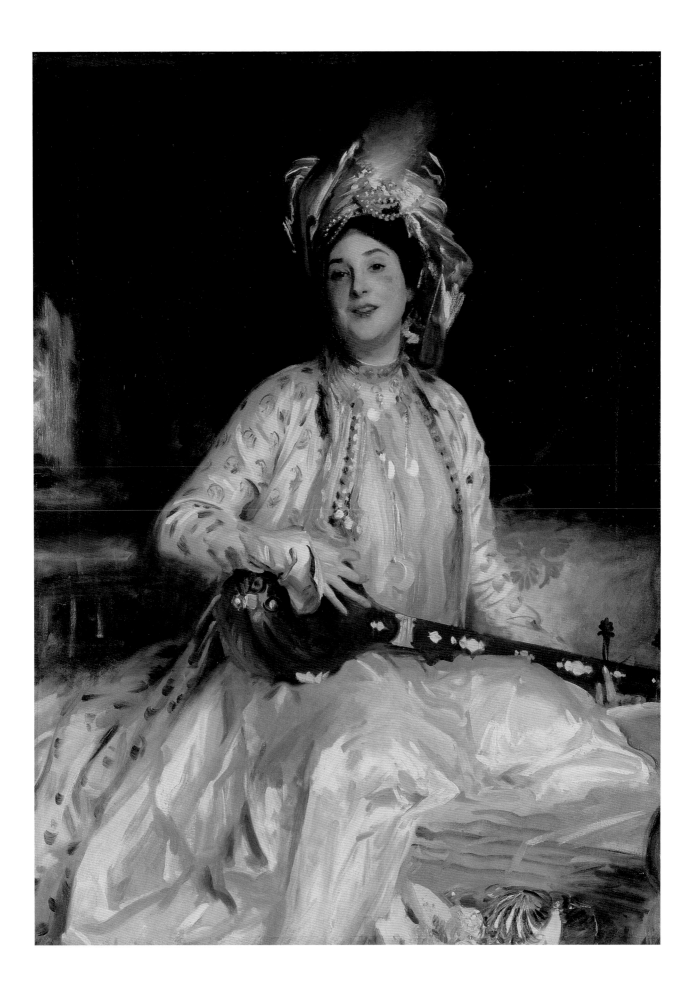

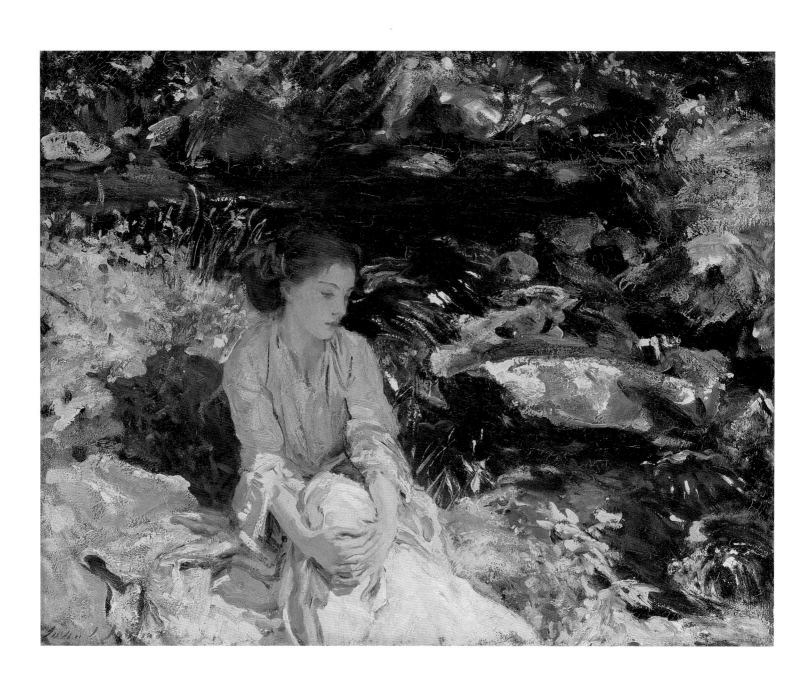

21 *The Black Brook,* ca. 1908

Oil on canvas
21¾ × 27½ in. (55.2 × 69.8 cm)
Signed lower left: *John S Sargent*
Purchased 1935

The brook is in the Italian Alps, near the village of Purtud, where Sargent had often stayed, painting mostly in watercolor rather than in the oils of this picture. He traveled with family and friends, whom he often used as models. In this case the seated woman is his niece Rose Marie, then aged about fifteen. Also in this year he painted her younger sister Reine, aged eleven, in a sequence of poses in a single painting, called *The Cashmere Shawl* (private collection), since she is wearing the long, enveloping shawl that was one of Sargent's favorite dressing-up costumes. He was severely upset when Rose Marie was later killed in 1918 during the bombardment of Paris, near the end of the war.

The later landscapes by Sargent are so accomplished that it is easy to overlook their complexity. This scene by a mountain brook was painted in two (or more) separate occasions. Most of it was painted out-of-doors, but some parts, such as the touches of deep green, were painted later, probably immediately before it was exhibited at the New English Art Club in London in 1909. The picture contrasts light and shade, as the body and head of the figure are in the shade, but her hands hugging her knees are in bright sunlight. In the background, splashes of water catch the sunlight. The painting of her ten interlaced fingers is brilliant, without appearing anything other than the simple truth. The status of the picture is unusual, in that the figure is of just the scale to be midway between a portrait and a figure in a landscape. Sargent had sought earlier on a means of making portraits in natural light, which he finally achieved in the special conditions of clear mountain air and an obliging subject within his family.

22 *Venetian Fishing Boats*, ca. 1904

Pencil and watercolor on paper
19¼ × 13¾ in. (48.9 × 34.9 cm)
Presented by Lord Duveen 1919

23 *The Piazzetta, Venice*, ca. 1904

Watercolor on paper
13½ × 21⅛ in. (34.3 × 53.7 cm)
Signed lower left: *John S Sargent*
Presented by Lord Duveen 1919

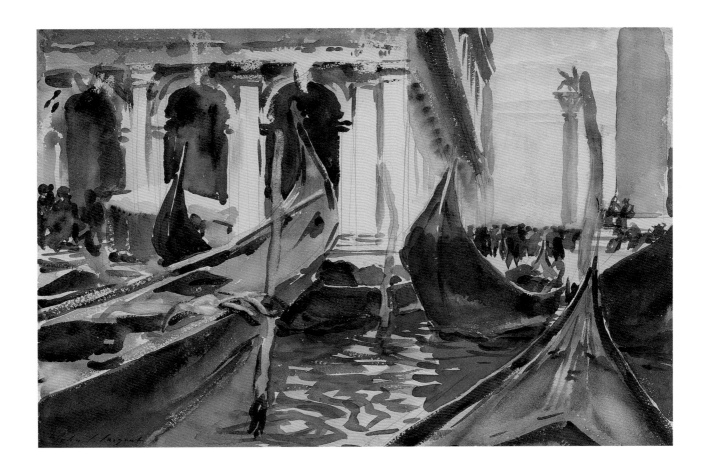

Venice has been described as Sargent's second home in the early years of the twentieth century, since he visited there regularly in the summers and early autumns. As a young man he had painted a series of sketches in oil of young Venetians in the city, and twenty years later he painted in watercolor the tourists' Venice, grand buildings and picturesque gondolas. Though his subjects were conventional, he took a particular point of view, often cropping the images or showing the edges or interconnections of buildings. He often worked from a gondola, as seems to be the case in both these watercolors, and he painted for the most part directly in color, using little preparatory drawing. Sometimes he chose subjects as if he were seeking the most difficult to paint, such as the complex rigging in *Venetian Fishing Boats*. In *The Piazzetta* there is a deliberate confusion of scale, looking from the prow of his own boat, past crowds of people, and down the steep perspective of the edge of the famous library building by Jacopo Sansovino (the detail of which Sargent did not record accurately).

Miss Eliza Wedgwood and Miss Sargent Sketching, 1908

Watercolor and gouache on paper
19¾ × 14 in. (50.2 × 35.6 cm)
Signed lower left: *John S Sargent*
Bequeathed by William Newall 1922

Emily Sargent, the artist's younger sister by a year, who was an amateur artist, is shown here painting a watercolor landscape, while Eliza Wedgwood, a family friend, sits beside her. Sargent painted them in Majorca in the autumn of 1908, where he had rented a villa in the village of Valdemossa. This is one of many watercolors and oil paintings from about this time that he made of his traveling companions, who formed a small group of constant friends. It is as if Sargent were isolated from the world by this company, whom he always shows remote from any aspect of contemporary life, painting, traveling, visiting gardens, asleep, or regarding each other. This watercolor is also one of his many views of other artists at work, comparable to the earlier painting of Monet sketching at Giverny.

25 *Oxen, Carrara,* 1911–13

 Pencil and watercolor on paper
 15¾ × 20¾ in. (40 × 52.7 cm)
 Signed lower left: *John S Sargent*
 Presented by Lord Duveen 1919

26 *San Vigilio, Lago di Garda,* ca. 1913

 Watercolor on paper
 14¼ × 21 in. (36.2 × 53.3 cm)
 Signed lower left: *John S Sargent*
 Presented by Lord Duveen 1919

There are a number of watercolors by Sargent of oxen he saw in Italy, and this page painted at Carrara consists of several different sketches put together. His group stayed at the village of San Vigilio on Lake Garda in 1913. He had written to a friend: "The de Glehns my sister and I are off in a day or two to the Lake of Garda, where we have discovered a nasty little pension on a little promontory, which is otherwise paradise—cypresses, olives, a villa, a tiny port, deep clear water and no tourists."[1]

Sargent regarded his watercolors as important and took care to compile three collections of good work to sell to American museums, at Boston, Brooklyn, and the Metropolitan Museum. These four watercolors given to the Tate Gallery by Lord Duveen, a patron of both the collection and the new building of the gallery, were also in a much smaller way intended as a representative group.

1. Quoted in Evan Charteris, *John Sargent* (London: William Heinemann; New York: Charles Scribner's Sons, 1927), 171.

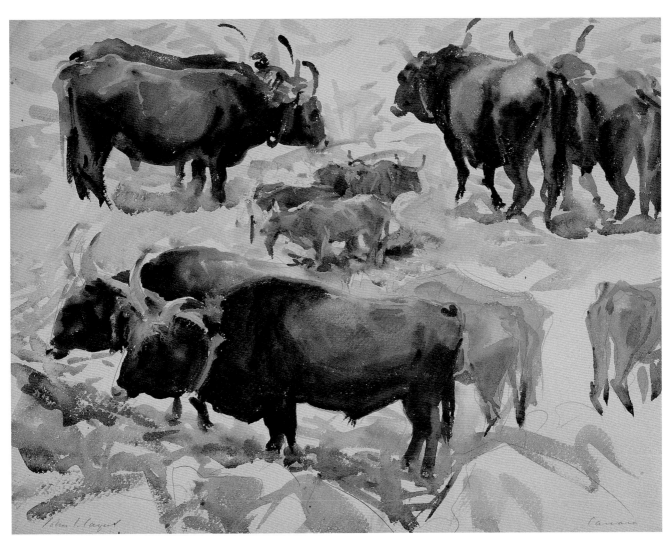

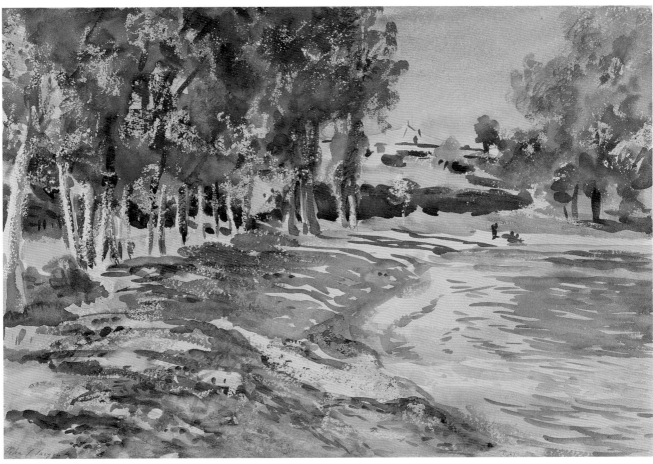

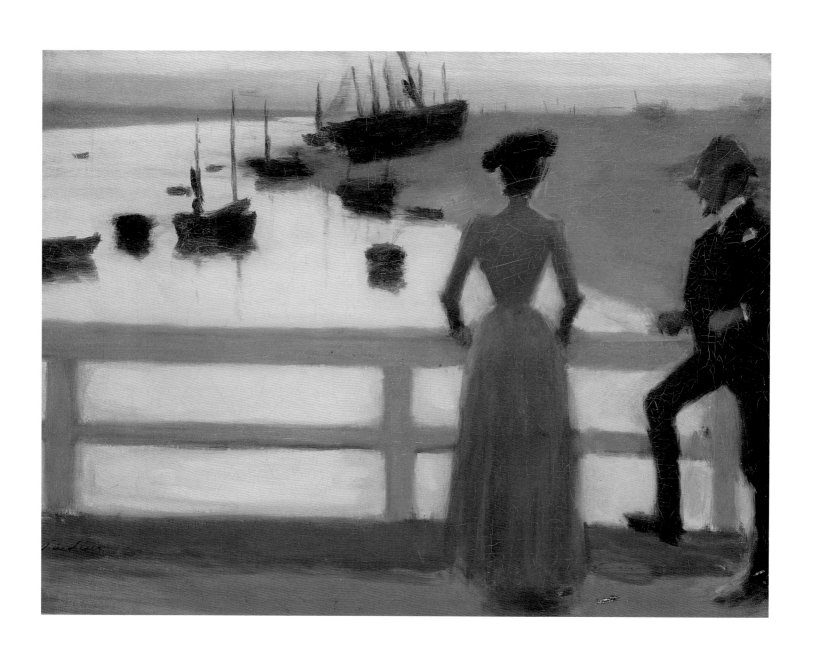

Philip Wilson Steer
(1860–1942)

27 *The Bridge,* 1887–88

Oil on canvas
19½ × 25¾ in. (49.5 × 65.4 cm)
Signed lower left: *P. W. Steer*
Purchased 1941

The Bridge was painted at Walberswick in Suffolk, a small town on the east coast of Britain, where there was a beach popular for bathing. Steer went there for the first time soon after he returned from living as a student in Paris in 1884, and for the following seven years until 1891 he went there to paint in the summer almost every year.

The painting is designed carefully, with the parallel railings at the lower edge and the two figures in conversation placed at one side. Steer had made an oil sketch out-of-doors of a similar view, with only one figure, shortly beforehand on the coast near Etaples in Normandy in northern France. He adapted the design of that earlier sketch in this painting, which is so carefully controlled that it is likely to have been painted in the studio, using drawings made on the spot. At Etaples, Steer had also painted figures on the beach seen against reflected sunlight, and at Walberswick he again painted the poetic effect of figures contrasted to light, in this case an evening light reflected from the estuary.

Steer exhibited this picture for sale at the Grosvenor Gallery in 1888. His style was then unfamiliar and more extreme in technique than that of any other artist working in Britain. *The Bridge* was consequently attacked in the press as "a deliberate daub,"[1] a criticism provoked probably by the unusual twilight colors with a mauve tonality, and by the lack of detail.

1. D. S. MacColl, *Life, Work, and Setting of Philip Wilson Steer* (London: Faber and Faber, 1945), 26, quoting the *Daily Telegraph.*

28 *Figures on the Beach, Walberswick,* ca. 1888–89

Oil on canvas
24 × 24 in. (61 × 61 cm)
Purchased 1947

Steer's paintings of children on the beach and of sailing ships near the coast, made between 1888 and 1894, are remarkable for their brilliant sunlit coloring and the summary drawing of the figures, typically in red and blue brushstrokes. They are the climax of his Impressionist style, which he developed over these years after the example of Monet, whose recent paintings had been exhibited in London. Steer had a habit of repainting these pictures after he had first exhibited them, and it is difficult to know precisely when each was made.

This schematic view with markedly broken application of paint shows at the right three girls, seen from behind as they stand on the pier at Walberswick. They are looking across the sands at low tide, where adults and children are playing on the beach, toward the sea with a group of large sailing boats on the horizon. It is likely that the picture was itself painted out-of-doors.

It is possible that this picture was included in a group exhibition titled *London Impressionists,* which was organized by the artist Walter Sickert at the Goupil Gallery in December 1889. Sickert and Steer were the leading painters, but the artists did not exhibit again as a group, and Steer was not often a painter of subjects in London.

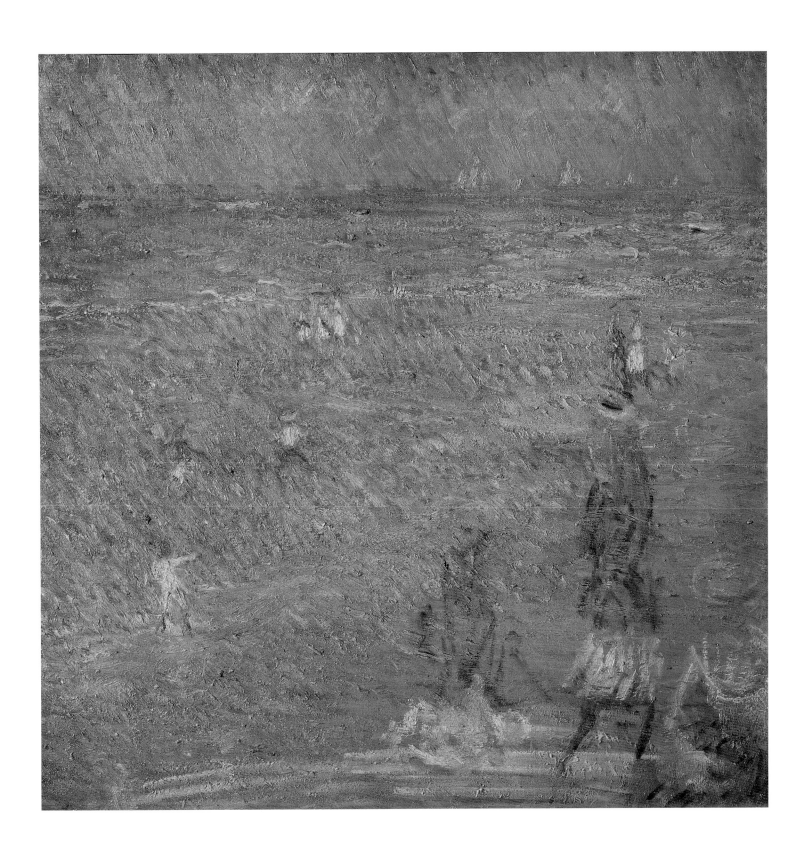

29 *The Beach at Walberswick*, ca. 1889

Oil on canvas
23¾ × 30 in. (60.3 × 76.2 cm)
Purchased 1942

Three girls, possibly a mother with her two daughters, stand and sit on the end of the pier at Walberswick in Suffolk, with two miniature dogs. It is low tide, and they look across a pool toward some figures on the beach and some sailing boats out at sea. Two of the girls have long golden hair and boots with high heels. In one of Steer's sketchbooks (all of his sketchbooks are preserved in the Victoria and Albert Museum, London) there is a similar scene, and he wrote beside them "yellow/yellow gloves/black bodice/warm pink/warm shingle" (E 275-1943, pp. 30–31). Steer is carefully repeating the color of the three figures and gathering them into a group, so that they look like the same figure seen three times. Although the painting was dated 1893, this drawing is with others that were probably made in 1888, and it is likely that the picture was first painted at this earlier date and retouched and signed later.

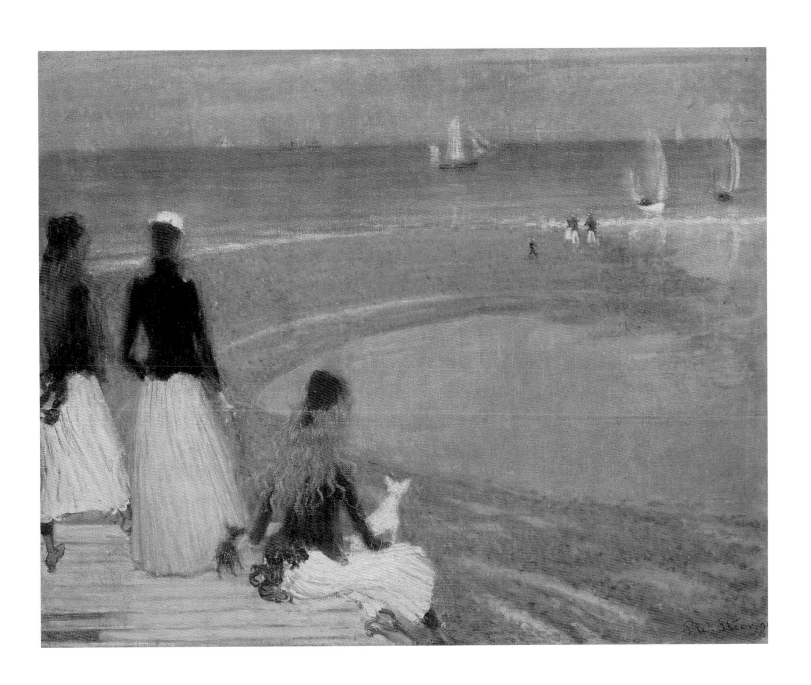

30 *Southwold,* ca. 1889

Oil on canvas
20 × 24 in. (50.8 × 61 cm)
Purchased 1942

Southwold is on the Suffolk coast near Walberswick, on the opposite and northern side of the river Blyth. This painting was not exhibited by Steer and not overpainted by him, and is a striking example of his freedom in coloring and in drawing. The colors are intense and are drawn with the brush rather than painted in patches. It can be seen from Steer's sketchbooks that he drew in front of his subjects in pencil very quickly and without outlines, marking the paper with a variety of lines and dashes to create a shorthand version of a figure before him. This sense of immediate apprehension is evident also in the paintings. A sketchbook mostly drawn at Walberswick includes a sketch for the women sitting on a bench in this painting.

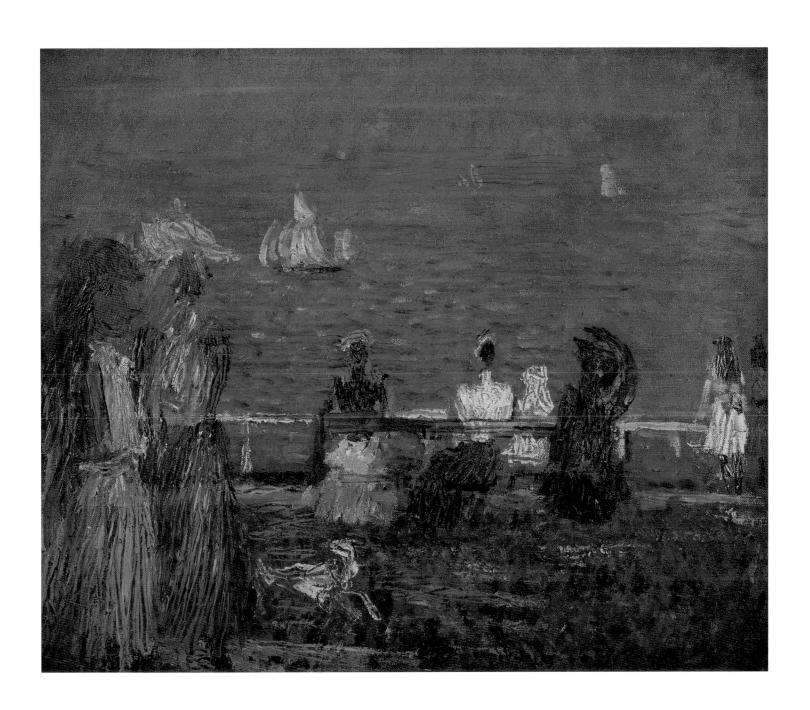

31 *Boulogne Sands,* 1888–92

Oil on canvas
24 × 30⅛ in. (61 × 76.5 cm)
Signed and dated lower left: *P. W. Steer 92*
Presented by the National Art Collections
Fund 1943

Steer painted in Boulogne in 1888, and then later in 1894. A sketchbook he used in 1888 (Victoria and Albert Museum, London) includes two drawings of girls playing around a sand castle with a view of the open beach, with bathers and beach huts behind them. The oil was probably mostly painted in about 1888 but retouched before Steer's exhibition at the Goupil Gallery in February 1892. He also painted a number of small out-of-doors oil sketches on the beach at Boulogne. None is clearly connected with this painting, but they indicate that his method was both to sketch rapidly in black chalk in drawing books and to paint out-of-doors on wooden panels. A large painting such as *Boulogne Sands* was probably painted in the studio.

A critic praised this painting at length in a review of the 1892 exhibition:

"Boulogne Sands" is the very music of color in its gayest and most singing moments, and every character and association of the scene helps by suggestion in the merry *fête* of light. The children playing, the holiday encampment of the bathers' tents, the glints of people flaunting themselves like flags, the dazzle of sun and sea, and over and through it all the chattering lights of noon—it is like the sharp notes of pipes and strings sounding to an invitation by Ariel.[1]

1. MacColl 1945, 45, quoting an article by George Moore published in November 1892.

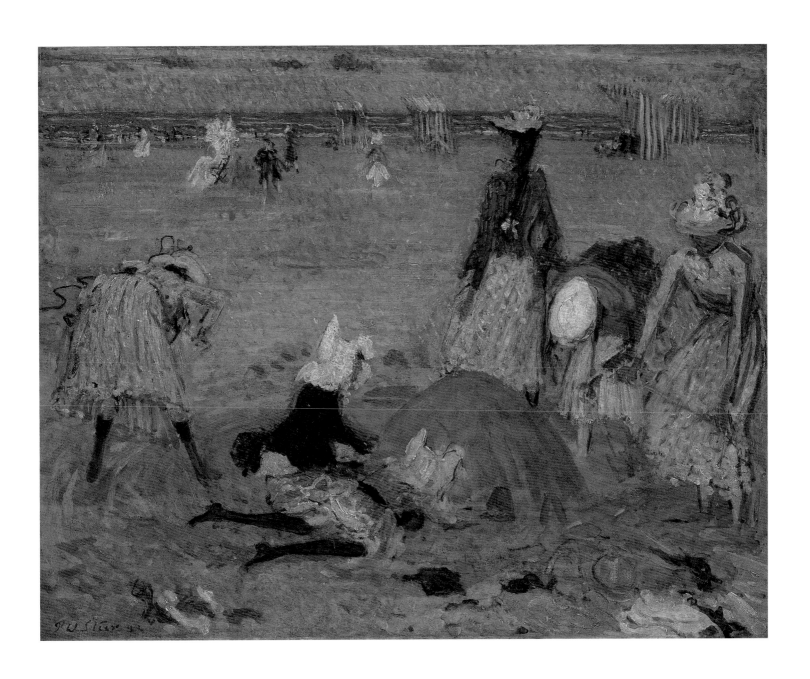

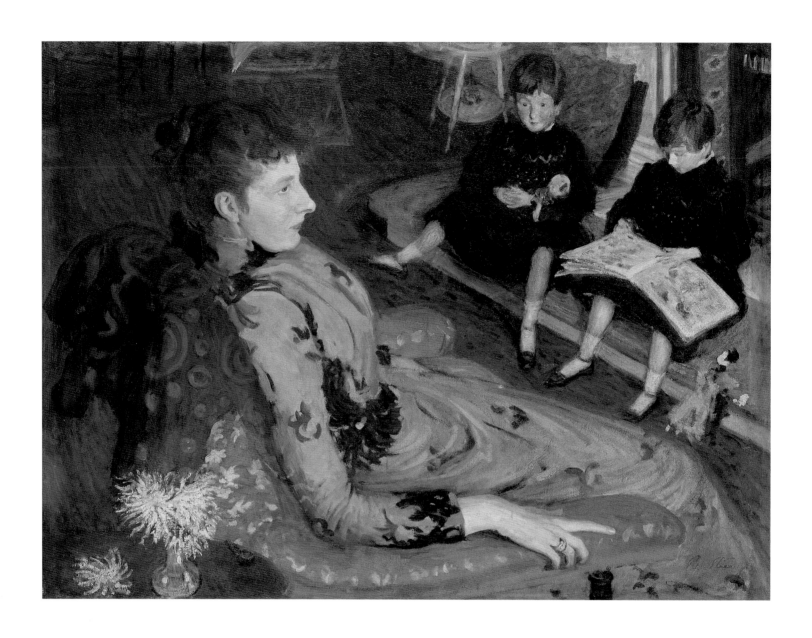

32 *Mrs. Cyprian Williams and Her Two Little Girls,* 1891

Oil on canvas
30 × 40¼ in. (76.2 × 102.2 cm)
Signed lower right: *P. W. Steer*
Purchased with assistance from anonymous
subscribers 1928

Mrs. Williams was an artist who exhibited with Steer at the New English Art Club, and her husband, T. Cyprian Williams, was a collector of art. D. S. MacColl, the artist's biographer, recalled that the portrait was commissioned by another artist friend of Steer's, Francis James. There is no record of the portrait's belonging to the sitter's family, and it may be that it was painted at Steer's request, but he needed the commission to be able to devote the time to it. The design of the portrait is unconventional in that the point of view looks downward from one corner. Mrs. Williams is seen in profile, and her two daughters, placed on a bench that divides the picture diagonally, are seen from above. Steer was freer to be unusual as the portrait was not being paid for by the sitter.

MacColl noted that Steer was imitating the complex design of paintings by Degas and of Japanese prints: "A curiosity in perspective grouping, traceable to Degas or Japanese design, marks Mrs. Cyprian Williams and her Children."[1] The portrait was exhibited at the New English Art Club in 1891, where Steer was competing with Sargent, who also favored unusual compositions and often emphasized, as does Steer, the sitter's hands. The connection with Japanese prints is made explicit by the additional tokens of the two Japanese dolls and the Japanese fabric on the back of the armchair.

1. MacColl 1945, 101.

33 *Girl in a Blue Dress,* ca. 1891

Oil on panel
10¾ × 8¼ in. (27.3 × 21 cm)
Signed upper left: *P. W. Steer*
Bequeathed by Sir Hugh Walpole 1941

Steer was known in his early career as much as a painter of portraits and figures as for his now more popular Impressionist landscapes. Besides the commissioned portraits he also painted models seated in his London studio, often lit by lamplight. These are effectively interior equivalents of the out-of-doors beach scenes, since they are again focused on a young girl, but seen on a larger scale, and at rest. They follow the same changes in painting style as his landscapes, although less extreme in technique, and at the time he painted this small sketch Steer was also using clear colors and a direct, Impressionist application of paint.

For eight years from 1889 almost all these studies are of a single model, Rose Pettigrew, whose pictures Steer sometimes exhibited under her own name, such as the *Pretty Rose Pettigrew* shown in the *London Impressionists* exhibition of 1889. Bruce Laughton suggests that although she

did not pose for any of his Walberswick pictures—the girls on the pierhead appear more like passing visions, recreated in his mind—she may well have been the concrete basis, as it were, for his predilection for thin, auburn-haired or red-haired schoolgirls. She was aged "nearly 12" when she met him. . . . Steer's romantic feelings for very young women, which we have seen idealized in the Walberswick pierhead pictures, may have had its roots in the reality of this one documented relationship.[1]

In old age Rose Pettigrew wrote a memoir of her life. As a little girl she and her sisters had earned quite large sums of money by posing for many of the late Victorian painters and sculptors, and she lists John Everett Millais, Whistler, Edward Poynter, Onslow Edward Ford, Frederic Leighton, William Holman Hunt, Val Prinsep, John Gilbert, John Tweed, and Sargent. She was evidently closest first to Whistler, and then to Steer.[2]

1. Bruce Laughton, *Philip Wilson Steer, 1860–1942* (Oxford: Clarendon Press, 1971), 43.
2. Pettigrew's memoir was first published in Laughton 1971 as Appendix 1, 113–21.

34 *Girls Running, Walberswick Pier,* 1888–94

Oil on canvas
24¾ × 36½ in. (62.9 × 92.7 cm)
Signed and dated lower right: *Steer 94*
Presented by Lady Augustus Daniel 1951

Girls Running, Walberswick Pier is one of Steer's best-known paintings. It is one of his largest Impressionist paintings and also one of those he most reworked, as can be seen from its thick surface of paint. A drawing in a sketchbook he used in Walberswick in 1888 (Victoria and Albert Museum, London), which shows three girls holding hands as they run beside the sea, with their bodies visible through their loose clothes, may be the origin of the running girls in the foreground. They are like an animated and more everyday version of Steer's huge painting of three nudes, *A Summer's Evening* (1888; Jenkins, fig. 13). The three figures in the background also take up an idea from an earlier painting, the figures in *The Beach at Walberswick* (cat. 29). Bruce Laughton wrote of this:

It can be read as a deliberate attempt to summarize the atmosphere of Walberswick for ever . . . a mixture of fleeting memory and imagination. It has a strange, compelling awkwardness about it. The orange faces of the running girls, their long spindle-shaped shadows, echoed by more shadows cast by unseen spectators in the foreground, and the whole color scheme in a characteristic Steer key of ultramarine and vermilion, all carry an unusual *supra-reality* which is closer to Bonnard in spirit than to the classic French Impressionists of the seventies and early eighties.[1]

The painting is dated 1894 and was included in Steer's one-man exhibition at the Goupil Gallery in February that year.

1. Laughton 1971, 22.

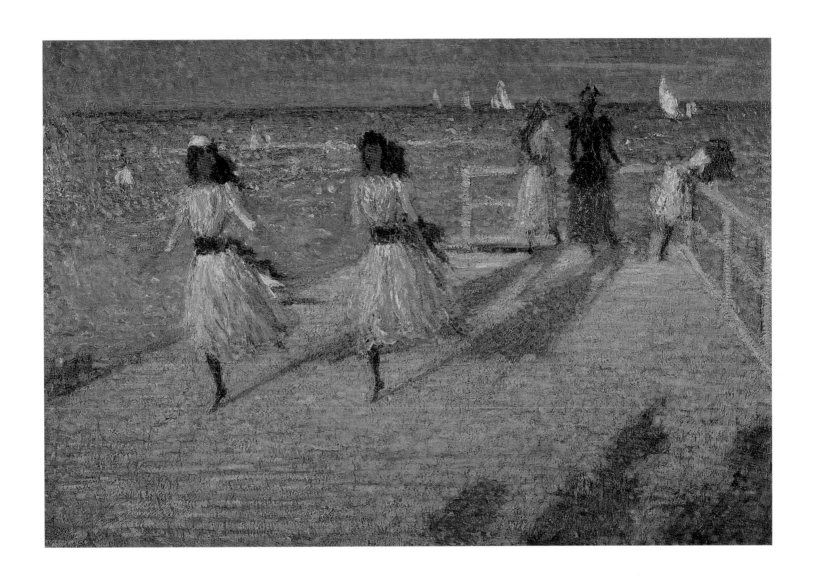

35 *A Procession of Yachts,* 1892–93

Oil on canvas
24¾ × 30 in. (62.9 × 76.2 cm)
Signed and dated lower left: *Steer 93*
Purchased 1922

Steer painted a number of pictures of yachts racing at Cowes, on the Isle of Wight (off the south coast of Britain), where he stayed for the second time in the summer of 1892, after also painting there in 1888. The regatta at Cowes was one of the most fashionable of all sporting events in Britain. Three of his sketchbooks of 1892 are filled with studies of yachts and of figures seen from behind watching them. In this view there are two yachts with sails furled, moored in the foreground, while a group of yachts race past behind them. The painting was exhibited at the New English Art Club in November 1892 and then again in Steer's one-man exhibition at the Goupil Gallery in February 1894, and it was partly retouched by Steer between these two shows. Steer's biographer D. S. MacColl, who disliked "neo-impressionist" painting—the style invented by Georges Seurat of painting in little dots of color—remarked that this was the only picture painted in this way by Steer. He suggests that Steer had seen paintings by Seurat and by Camille Pissarro of yachts.

36 *Chepstow Castle,* 1905

Oil on canvas
30⅛ × 36⅛ in. (76.5 × 91.8 cm)
Signed and dated lower left: *P. W. Steer 1905*
Presented by Miss Mary Hoadley Dodge 1909

Chepstow Castle, perched on a low cliff above the river Wye in Monmouthshire, on the border between England and Wales, is well known as a historic and attractive view and had been painted by many artists beginning in the eighteenth century. From 1895 Steer deliberately sought such scenes, choosing to paint especially the most dramatic-looking castles in open landscape in Britain, such as at Richmond in Yorkshire, where he went in 1895 and again in 1903, and at Ludlow, which he visited often from 1898. He knew the area of Chepstow well as he had grown up at Whitchurch, near Ross-on-Wye a few miles away, but in a letter he records a surprisingly roundabout way of coming to this subject, after touring northern and central Wales looking for paintable subjects. The particular difficulty he had was finding a suitable point of view. His method of work was to make drawings and watercolors on the spot and then to paint in a large room hired somewhere in the area, taking the painting back to London to complete or to begin again in other versions. In 1905 he painted another view of Richmond Castle, copied from earlier paintings, with the castle as a backdrop illuminated from behind, making a striking outline. This design was repeated with the castle at Chepstow. In all, Steer made four versions of this view of Chepstow.

Bruce Laughton makes the point that Steer used different manners of painting for different views and light effects. He compares this view of Chepstow with the exactly similar viewpoint recorded in J. M. W. Turner's *Liber Studiorum,* a set of prints made after Turner's paintings. Steer knew these prints well, and was certainly aware of the comparison. The handling of paint here is most reminiscent of the sketchy application of light colors over dark that was used by John Constable:

Steer sought out Turner's viewpoint and painted a modern picture of it—several, in fact, . . . although the Tate painting is the best. The blonde tonality of its highlights, with the shadowed rocks palette-knifed in greenish-grey sets up the kind of impressionist vibrations in a minor key now characteristic of Steer. The *contre-jour* effect of light is one which has recurred in his work since Etaples in 1887, though the spontaneous quality of this particular painting now relates more to Constable's painting style.[1]

This was the first painting by Steer to belong to the Tate Gallery. It was given by the American collector Mary Hoadley Dodge in 1909, the year it was first exhibited, at the New English Art Club.

1. Laughton 1971, 93–94.

37 *The Church at Montreuil,* 1907

Oil on canvas
19¾ × 24 in. (50.2 × 61 cm)
Signed and dated lower left: *P. W. Steer 1907*
Presented by Owen Fleming 1953

38 *The Outskirts of Montreuil,* 1907

Oil on canvas
38 × 48 in. (96.5 × 121.9 cm)
Signed and dated lower left: *P. W. Steer 1907*
Bequeathed by George E. Healing 1953

Montreuil-sur-Mer is about ten miles inland from Le Touquet (and so is not, as the name implies, on the sea) and is the first large French town reached by travelers from Britain going to Paris by the direct road south from Boulogne. Steer had been there in 1889, when he painted two Monet-like pictures, one of poplar trees by the river and another of the town's old fortifications. In 1907 he returned to spend the summer painting there, after a long interval during which he chose to paint in Britain, where he had gradually developed a style that in coloring and subject was closer to Turner and Constable than to the Impressionists. But that autumn, after his stay at Montreuil, he went on to Paris to see the Paul Cézanne retrospective exhibition at the Salon d'Automne in October, which had been assembled after Cézanne's death the previous year. Bruce Laughton has suggested that Steer's wish to go to France in 1907 followed from a renewed interest in the Impressionists. There had been a large group show of the Impressionists in London in January 1905 at the Grafton Galleries, organized by the French dealer Paul Durand-Ruel, which included a number of early Cézannes.

Steer rented a house in Montreuil, taking with him three artist friends, Fred Brown (the Slade professor at London University), W. C. Coles (from Winchester School of Art), and Ronald Gray. Steer's working procedure was to draw in pencil in a sketchbook while trying to find a suitable view, then to make oil sketches out-of-doors. A larger-scale painting was either completed back in his London studio from these or may also have been begun out-of-doors on the spot. *The Church at Montreuil* is a large oil sketch and was probably painted directly in front of the church. Steer considered such pictures as complete enough for sale and exhibited this at his one-man show at the Goupil Gallery in 1909.